JAN GROOVER

PLATE I

JAN GROOVER

PHOTOGRAPHS

INTRODUCTION BY JOHN SZARKOWSKI

A BULFINCH PRESS BOOK

LITTLE, BROWN AND COMPANY

BOSTON · TORONTO · LONDON

A CONSTANCE SULLIVAN BOOK

This book was developed, prepared and produced by

CONSTANCE SULLIVAN EDITIONS

First Edition

ISBN 0-8212-2006-3
Library of Congress Catalog Card Number 92-76090

Bulfinch Press is an imprint and trademark of Little, Brown and Company (Inc.)
Published simultaneously in Canada by Little, Brown & Company (Canada) Limited

PRINTED IN THE UNITED STATES OF AMERICA

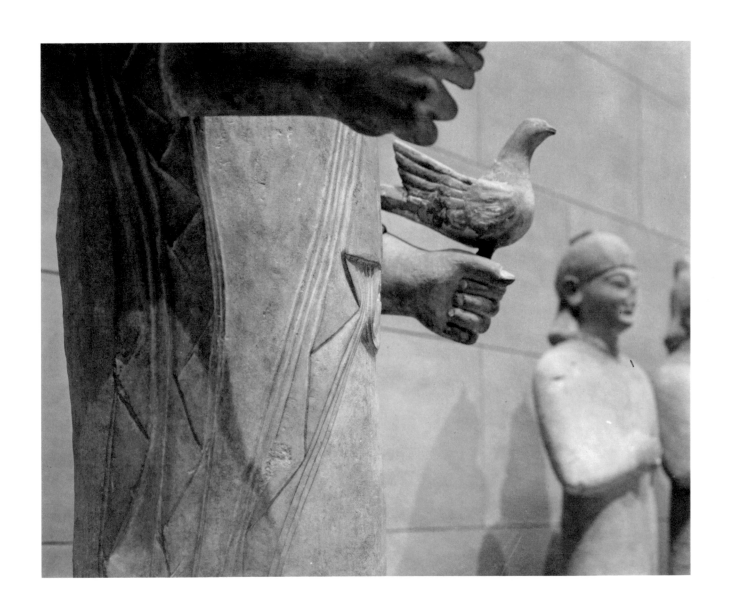

PLATE 2

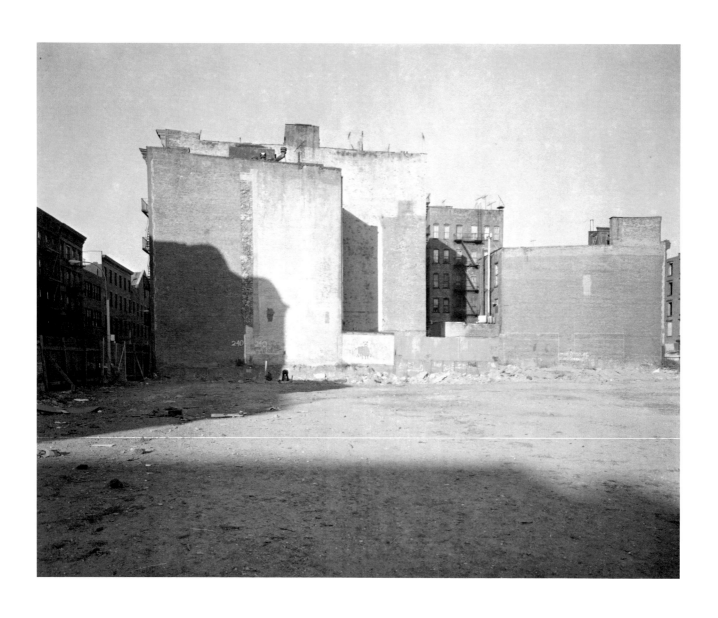

PLATE 3

THOUGHTS ON EVANS AND WESTON, LANGE, CARTIER-BRESSON, AND JAN GROOVER

It seems in retrospect that most of the best in American photography during the past half century can be related to a scale of sensibility and intuition that has at one end the work of Walker Evans, and at the other that of Edward Weston. Some might object that it is unfair to ask even these two superb artists to represent as spiritual fathers the whole pie of American photography's achievement during this rich period, and it is true that one might draw a more just, if less neat, picture if one proposed a triangular model, a short but broad-based pyramid with Weston and Evans at the two far points and Moholy-Nagy at the obtuse angle. Some might even claim that Weston and Evans stood close together on the scale of possibilities that were open to their time, since they both liked sharp pictures that used the entire gray scale, from black to white, and neither made double exposures or painted on top of their prints. But on a less superficial level their work was profoundly dissimilar, a fact clearly evident to Weston and Evans. Weston claimed that there was social significance in a rock, and Evans insisted that good photography was never under any circumstances done anywhere near the beach.[1]

It is of course foolish to try to find and define a simple principle that might explain the difference between these two giants, but it is impossible not to try: the difference is that Evans' pictures were about the life of the mind, and Weston's were about pleasure.

This is (of course) to say not that Evans is uninterested in pleasure, or Weston unavailable to intellectual concerns, but rather to say that their experience is filtered through such different modems that Weston's best ideas are given to us as pure sensation, and Evans' most passionate longings come disguised as ideas. Evans' work comes in an accent so cool and disengaged that we are persuaded that he shows us just the facts, and has no truck with feelings. Weston's world seems constructed of such beautiful fabrics, so beautifully

tailored, that we must constantly remind ourselves that his forms are also facts—the containers of worldly, nonartistic meanings.

Let us stipulate—even if only as a gross and provisional critical experiment—that most of the most ambitious American photography of the past half century bears a spiritual kinship either to Evans, on one hand, or to Weston on the other. If this is the case, it would seem to me that Evans has had, in general, somewhat better luck with his spiritual progeny than Weston. Beginning in the fifties, Robert Frank, Garry Winogrand, Lee Friedlander, Diane Arbus, and Robert Adams (with misgivings) are conspicuous among a large and impressively varied number of excellent photographers who have tried to spin their webs out of facts, and have eschewed free-floating beauty—beauty not anchored to some sort of tart Emersonian plain-dealing. On the other side of the family tree there are also contemporary photographers of great virtue and originality—Harry Callahan and Irving Penn and William Garnett, for example, but they were all born in the decade of the teens, only a generation younger than Weston. In the next generation I can think of only one whose work—for fecundity of invention and for quality—invites comparison with that of Edward Weston, and that one is Jan Groover.

Groover was a painter before she was a photographer, which should not be assumed to explain too much, since all painters are not cut from the same bolt of cloth, nor are all photographers; nevertheless it is part of the story, and we are entitled to assume that this early history disposed her to think of a picture as something that was made, not discovered. It is also true that when she first turned to photography she produced black-and-white diptychs, triptychs, and so on, that seemed quite close in spirit to the somewhat laborious head games being played by conceptual artists in the early seventies. But when she began to make somewhat similar pictures in color it quickly became clear that her pictures were good to think about because they were first good to look at. I mean, first, that her pictures were in fact good to think about, and second, that the ideas in them were so deeply imbedded in the aesthetic sensation that they were and are perhaps inextricable from it.

You might respond that this relationship is the universal condition of good art, and that it can therefore hardly be used as a means of distinguishing one good artist from another, and you would of course be right. Nevertheless, even though form and content are always co-extensive in a successful work of art (or let us assume so), it is not always the artist's strategy to allow this fact to show. Good expository prose, for example, is carefully designed to produce the illusion that the meaning and the means might be separated from each other, and that "the same thing" might be said otherwise. Prose also cultivates the idea that words are the writer's passive tools, mechanical containers of meanings that existed prior to and without reference to words. Poetry, on the other

hand, rejects this sophistry and allows the words to show their power. In these terms, Groover's art is like poetry.

Groover's first color triptychs generally were produced by combining three pictures made by a stationary camera and a changing subject, perhaps changed, for example, by a passing truck, whose trailer would for a second fill the frame with yellow. This manner of working has something in common with sports photography, or with photographing clouds, in the sense that no opportunity repeats itself; each must be seized now and intuitively or let pass, preferably without fruitless regrets. It is of course an exciting way of working; soon, however, Groover found that her options were richer if she allowed the camera also to move. Her options were richer in two ways: not only could she move her vantage point as she exposed the individual frames, but she was no longer bound by a given proscenium when she combined those individual frames in the triptych. This enhanced freedom allowed her not only to enrich the formal construction of her pictures, but to tell more complex stories, if one might be allowed to call them that.

One of the most beautiful works of this series is *Untitled*, 1977 (plate 6). For personal identification purposes it is not very useful to remember *Untitled*, 1977, so I think of this picture as Groover's picture about the Renaissance; it gives us borrowed architectural ornament, and excellent stone cutting, and a small catalog of vanishing points, indicating a constellation of infinities; more specifically it is about, as Susan Kismaric has said, the colors of Titian the portraitist: the ochres and umbers and cool grays of fur and leather and silk and the stone of damp Venetian winters. But it is also a photograph about New York, and about neighborhoods that learned about subtly declining expectations and the tabescence of ambition before these lessons were learned in other neighborhoods nearby; and it is not least about the patterns of patina laid onto well-cut stone by the hands of messengers and the mittens of small boys, who use the building's solidity to confirm their own.

One can claim that the picture is about these things, which are not altogether subjective or impressionistic or unavailable to confirmation; one could trace the sources of the ornamental motifs, and check the real estate tax records to follow the commercial fortunes of the buildings, and set a private investigator to watch the comings and goings of boys with mittens, etc., and finally describe on a graph the degree to which one's intuitions coincided with the objectively measured data, but even if one's intuitions were proved *perfect* it would in fact prove nothing. That is, it would not prove that the picture was about these little social and archeological and anthropological histories. If the histories are in the picture at all they could be said to be so thoroughly subsumed into the picture's own peculiar system of accounting, or information processing, or formal concern, that they are no longer at all what they were when they were free in the real world, any more than Cézanne's apples are something to eat.

We have all known for a long time that art comes from art, or at least primarily from art, and that Cézanne's apples are not something to eat, but rather an appreciation and a subsumption, into a new frame of artistic reference, of Chardin's apples, which were a purification of the rather mundane apples of the Dutch painters, which were a temporal, or capitalist, revision of the apples which Cranach and Dürer put in the hand of Eve, and so on. But we need not believe *absolutely* that art comes from art; it is in fact important *not* to believe it absolutely. Lawrence Gowing, both painter and historian, once transcribed a dialogue between a painter and an apple,[2] in which the apple identifies its role as serving as representative "of living form—the rounded face of nature." Similarly, in the case of Groover's *Untitled,* 1977, it is important to remember that—although in the normal course of our common technical conversation about the picture we might talk about Titian and Schwitters, and Edward Weston's picture of a detail of a country church at Hornitos, California—it also tells us something about the life of southern Manhattan. Or, if you are unwilling to go quite that far, you will perhaps at least agree that once the picture was made its meanings became part of the life of that place.

Groover seems insistent that a work of art lives and has its meaning exclusively within the chalk-lines of its own playing field, not in the journals or saloons in which it is discussed. I think that this is probably half true, and it is a position that I am more than half in sympathy with, since it means that the viewer is spared the task of taking into account the artist's psychic condition, social status, economic circumstances, digestion, life-style, and political stance before deciding whether the work adds anything of consequence to what one knew before seeing it. Nevertheless, once having been seduced by the work I am capable of finding myself interested in its relationship to the nominally extraneous issues listed above, except perhaps for digestion. In the case of Groover's work I am more inclined to be interested in these issues because she is so fastidious about excluding from her art any overt reference to autobiographical, much less confessional, materials. We are naturally more interested in those private lives that are not publicly exhibited. In these terms we might wonder at the source of the energy that in 1976 and 1977 produced a series of perhaps one hundred triptychs that seem to concern themselves with the character of middle-class, suburban, American life (plate 7).

That characterization is perhaps precipitate; I should perhaps rather say that these triptychs are constructed of individual photographs, made principally in New Jersey but also in other places within commuting distance of New York City, that show segments of well-painted clapboard walls, and well-pruned, well-fertilized trees and bushes, and flowers in bloom, and spaces between houses in which one might imagine that children have played children's games. These component parts, handsome in themselves, within limits, like a good piece of ledge limestone, are put together by Groover as a good mason builds a

good stone wall, to make something that is more ambitious, and broader in its aspirations. These pictures seem to me remarkable—beyond their native elegance—for doing something that might be unprecedented: they make the idea of suburban life something available to serious artistic consideration. John O'Hara and others have of course made good artistic use of the suburbs, but have done so by working fundamentally in the ironic voice, using the suburb as the seat of something not genuine, an imitation of something better. They have tended to agree with Auden, who said that only God can tell the saintly from the suburban. In Groover's pictures, in contrast, we see places where rich and simple lives might be lived at the junction of nature and culture. It is symptomatic of Groover's splendid equanimity toward her own experience that she made these pictures—composed of the stuff of the home and garden magazines—while living in a loft on the Bowery. Or perhaps it would be more to the point to say that her deepest experience is not that of her routine quotidian world, but that of the alternative world that we see in her work.

We have pointed out the advantages of diptychs and triptychs: if two or three pictures are framed together to make a new omnibus picture, the meanings of the individual pictures are modified by cooperation or confrontation. This is not a new idea in photography; forty years ago or more, the new meaning created by two photographs in juxtaposition was called the *third effect*, and it was of great interest to photographers as different as Dorothea Lange and Minor White. Lange made a number of diptychs as early as 1938, in the hope that such pictures could convey a clearer and more pointed social meaning than would be produced by the same two pictures if seen sequentially, away from each other's influence. One half of Lange's picture in figure 1 shows us a hitchhiker, a man who is down on his luck. The other half shows us a road that runs as straight as a surveyor's chain through country where there is no reason for the road to bend until one gets through the desert and into the mountains. If one puts the two pictures together the man becomes a migrant, leaving failure in the East and heading for the promise of California. The advantage of the combined form is clear, but since it is true that there is no such thing as a free lunch (perhaps even truer in art than elsewhere) we know that this advantage must be paid for. The payment—the disadvantage—is in fact almost the same thing as the advantage, seen from a slightly different angle: in the combined form the individual image is by definition incomplete and dependent, never allowed to stand alone. The meaning of the hitchhiker is more pointed but narrower.

Lange and Groover obviously used the diptych to very different ends, Lange seeking a sharper social observation, and Groover a more precise model of her most fundamental experience. Nevertheless, it is in the nature of the form that its component parts give up some part of their independence in the interest of the team meaning, which is composed

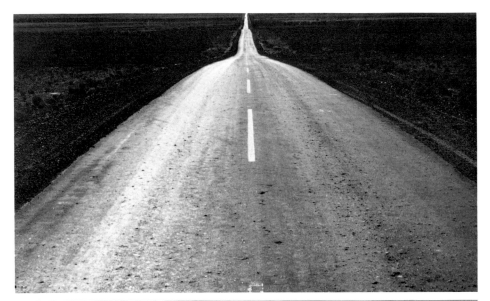

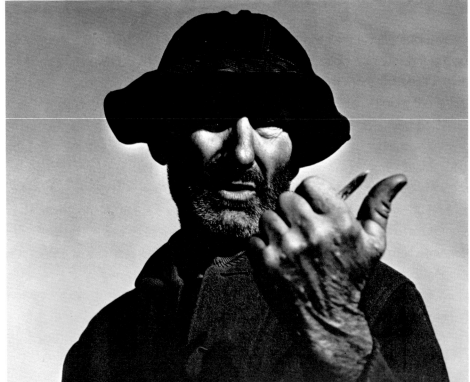

Figure 1.
Dorothea Lange. *The Road West, New Mexico*, 1938.
Gelatin-silver print, 7 1/2 × 9 1/2" (19.0 × 24.2 cm).

Untitled (Man Pointing) no date.
Gelatin-silver print, 7 1/2 × 9 1/2" (19.0 × 24.2 cm).

The Museum of Modern Art, New York. Gift of the Photographer.

not by simple but by compound addition—it is the sum of the first half plus the other half, plus both halves seen together.

This being the case, one might hazard the guess that Groover, having worked intensively with combined forms for at least five years, eventually decided that she would like to try to complete the picture with a single blow, in tribute to the intuition that economy of means is a basic artistic virtue. After 1977 it seems that Groover has not again used the combined forms, or has at least not publicly shown work that she may have done in this vein.

In 1978 and 1979 she did an extended series of large color still lifes of kitchen utensils and fruit, in which she combines an almost abandoned richness of color and surface with a rigorous, classically modernist picture structure (plates 10–17). The union of voluptuousness and precision was irresistible, and the series was a great commercial success as well as an artistic one. It is characteristic of Groover that the homely spatulas and colanders in these pictures seem transformed not by irony or metaphor, but by something similar to disinterest: they seem here the instruments of a technology that is elegant, unfamiliar, and adventurous. They remind us not of the scullery, or even of *haute cuisine*, but perhaps of instruments of navigation, or devices for precise measurement.

In these pictures Groover achieves a complexity and richness comparable to that of the triptychs by constructing in front of the lens a subject designed to be photographed. More precisely, these subjects are not merely constructed to be photographed, but are constructed in terms of the appearance of the image on the groundglass, as drawn by the lens and the view camera, and constructed also in terms of the way in which that image is recorded by the chemical nature of the materials she was using. This series continued into 1980, and at least some of these last pictures of the group are color photographs that describe subjects that are almost purely monochromatic. These pictures are perhaps the source, or at least the beginning, of Groover's meticulous investigation of the platinum printing process. Photographic prints made in platinum (or platinum and palladium) seem to divide the distance between black and white into more segments than is the case with the customary silver print, rather like a piano that might divide the intervals between the highest A and the lowest C in half, and play quarter-tones.

But all these quarter-tones are not in themselves necessarily useful or beautiful. And like the 175-keyed piano, the platinum print can fall into the trap of valuing subtlety for its own sake, which vice soon descends further into a lugubrious grayness. In order to justify the character of its beauty, the platinum print should embody a photograph that is full from corner to corner with the intelligent description of light and surface. Writing of the Hampton Institute photographs—platinum prints—of Frances Benjamin Johnston, Lincoln Kirstein described the quality of her subjects[3], seen in the watery, opalescent sunlight of autumn, as their "fine-grained taffeta shimmer," which is perfect. It is pointless to quibble that he is

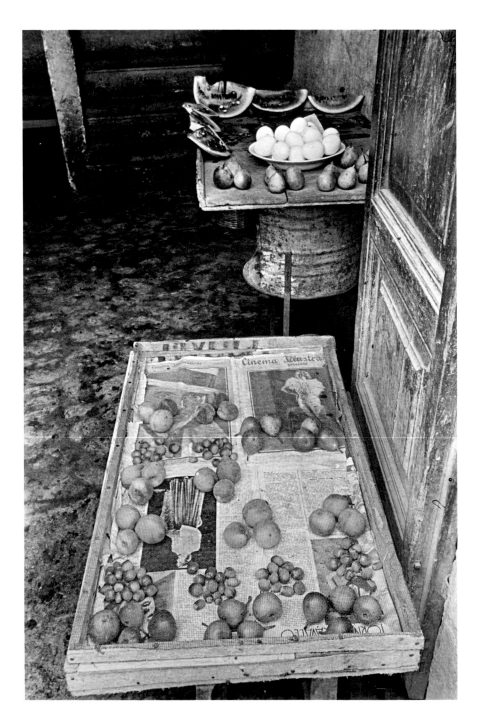

Figure 2.
Henri Cartier-Bresson. *Tivoli,* near Rome, 1933.
Courtesy Magnum Photos, Inc.

describing not the subject but the picture, since the photographer's success has made them indistinguishable.

Perhaps the most memorable of Groover's early works in platinum are from the series of New York cityscapes of the early eighties (plates 3 and 33). These pictures of empty lots and not quite abandoned buildings show us a city that has shed its problems and its people and assumed a new life as a beautiful ruin, as poised and graceful as the Acropolis, and bathed in no less beautiful a light. The astonishing serenity of Groover, the quality that keeps her as an artist out of harm's way even in the suburbs of New Jersey and the rookeries of Manhattan, here transforms the virtue of balance almost to a perversity.

Since her beginnings as a photographer, Groover has, it would seem, worked her way deliberately and methodically through a series of problems of great breadth, complexity, and subtlety, as though determined to strip the medium of every secret that might submit to talent guided by intelligence and devotion. This is a little too sweeping; one might except from the syllabus of Groover's self-instruction most of the photographic problems that we would file under the main topic heading of *Henri Cartier-Bresson, legacy of.* At least insofar as Cartier-Bresson's photographic interests have been intimately tied to the kinetic and the ephemeral, Groover works a different vein. Nothing has moved in her photographs, not a blade of grass in the wind, since the moving trucks of the early triptychs—except, once and slightly, her cat.

Her disinterest in the ephemeral might actually be considered not a passive omission but a central principle. It is interesting to note that during the past decade the picture edge in Groover's still lifes has become much less active than it was earlier. Formerly in her work the edge had performed its central, classic role as the device with which the photographer edits from the chaotic world a few square inches of order. This manner of working recognizes by implication the existence of a world beyond the picture edge, and also the possibility of change, since a slight movement of the camera would show us different facts. Groover's later work is more insistently self-contained; the picture edge is like the wall around a sculpture garden, defining and protecting the purity and independence of the world inside.

If Groover has been unconcerned with the ephemeral, except in its longest, slowest rhythms, she is profoundly involved with a different problem to which Cartier-Bresson has also been consciously alert, which is the nature of photographic drawing—the ways in which lenses and photographic materials *indicate* things. It is obviously true that Cartier-Bresson's interest in the issue has been circumscribed by the technical vocabulary within which he has worked, and also by other priorities which have sometimes taken precedence over his interest in formal problems. Nevertheless, pictures like *Tivoli,* 1933 (figure 2), of the makeshift fruit stand, and *Jean-Paul Sartre,* 1946, of the philosopher on the Pont des

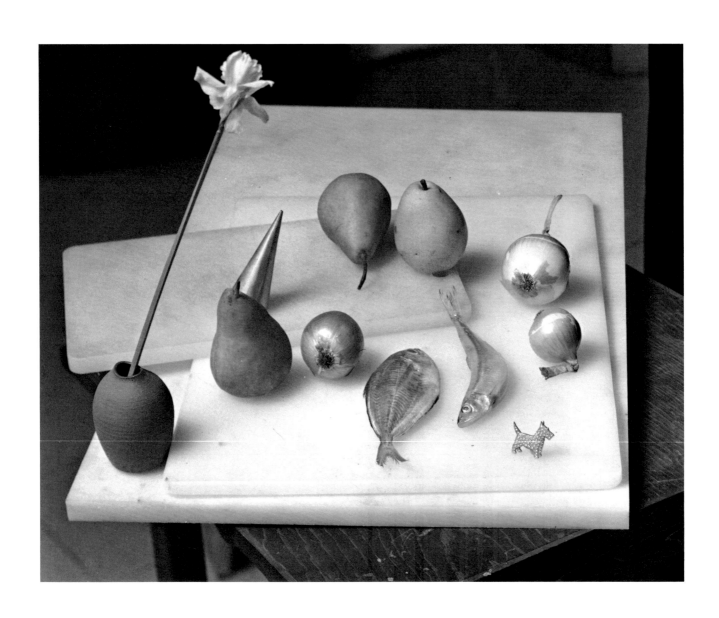

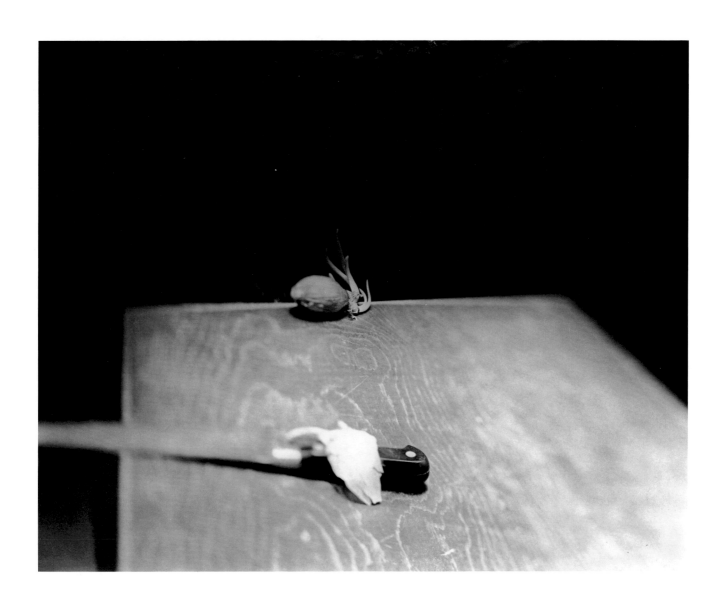

PLATE 5

Arts, imprisoned in the dank gray qualification of the Paris winter, make it clear that the photographer loved the special geometries and tonalities that are native to photography's descriptive abilities. Part of the great charm of *Tivoli* lies in the subtle, asymmetrical, eccentric perfection of its perspective drawing, the whole patchwork of inclined planes, spheres, circles, cylinders, arcs, and cones rendered precisely true, with no tidying up of the not quite parallel lines for the sake of conceptual neatness. Groover's superb still life *Untitled, 1983* (plate 4), might be seen as an homage to *Tivoli*, although it was of course constructed very deliberately, not caught *à la sauvette*, so to speak. In addition, the camera that Groover worked with is very different from Cartier-Bresson's Leica, which is a rigid box that holds the film in a fixed relationship (perpendicular and centered) to the central axis of the lens. Groover's camera is in contrast rather like a simple accordion, which allows the relationship of lens and the plane of the film to be varied in a number of important ways. (These adjustments, called "movements," were first developed [4] to allow the camera image to conform more closely to the conventions of Renaissance perspective, which proposed, for example, that while parallel lines in a horizontal plane converged toward a vanishing point, parallel lines in a vertical plane did not.) These camera "movements" allowed photographers to make photographs of buildings that resembled more or less closely the drawings made by architects. There was of course no reason why the same accordion could not be asked to play very different tunes, but I think that no one before Groover investigated this possibility so thoroughly. *Untitled, 1983* is an interesting case in point. The sensitive but unsuspecting viewer might, in confronting this picture, feel a vague sense of disorientation, which might persuade him or her to look long enough to form the opinion that it is a very oddly shaped table, and one inclined toward us at so dangerous an angle from the horizontal (reminding us of Cézanne's tables) that the objects on it seem in danger of tumbling forward; or to wonder why the pears in the background seem almost as large as the pear near the front of the table; or to question whether it is a clue of value that the stem of the jonquil, rising vertically, describes the same line as the edge of the table, receding into space. A valuable clue, or dust in our eyes?

The precise and scientifically valid optical projection recorded in this picture describes a more sophisticated case than we meet in the primers on perspective drawing, but it does not in any way or degree contradict the basis of Brunelleschi's or Alberti's idea, for the camera is in fact no more than a perspective machine. Those who might wish to understand what is happening in Groover's picture will do best by trying to duplicate it, which will I think be no more difficult, and more interesting, than the analysis of technical drawings that I doubt I would construct correctly. As a clue, I will point out that the central vanishing point in Groover's picture is no longer central; it is not somewhere on the vertical line drawn through the center of the picture, but somewhere on a vertical line drawn through

the picture near its right edge. One could produce this effect with a fixed box camera by composing the picture with the intention of later cutting off almost all of its right half.

In other pictures Groover has contorted her camera in other ways for other purposes: in *Untitled,* 1985 (plate 5), she has adjusted it so that the plane of sharp focus is not parallel to, or even approximately parallel to, the plane of the film. Instead the plane of focus slices into space almost perpendicular to the picture plane, like the path of an executioner's sword.

In the late eighties Groover became progressively bolder in making still lifes that were without ambiguity constructed to be photographed. It would not be altogether impossible to believe that the kitchen still lifes of the late seventies were actually discovered *in situ*, and photographed as they lay, like the stones of Point Lobos, although perhaps with a little adjustment of the lighting; but the subjects of the big still lifes of the late eighties (plates 46–56) are not only beyond doubt constructed and lighted for the purpose of being photographed, they are even lighted with lights with colored filters, and parts of the subject are even painted with paint from spray cans. The photographs that are then made of these constructions are not only pictures of remarkable beauty, not to mention flash and high style, but perhaps also tests that might help determine how far photography might move towards an art of synthesis without losing its analytic powers.

Her most recent work, in platinum again, still lifes again, has been made in the extreme horizontal format of the banquet camera (plates 57–59). The banquet camera was designed to photograph all of the people at a banquet, in the days when this was socially practical, and it therefore makes a picture about the proportion of a license plate, but half again larger. This lovely Edwardian relic was resurrected in the sixties by the late Art Sinsabaugh, who used it with great effect, first to photograph the Illinois prairie, making photographs that in some cases had little more for subject matter than the long horizon line. Illinois is of course not so easily rearranged as a few apples, pears, and knickknacks on a table, and it is not altogether clear why one would elect to use so cumbersome and recalcitrant a machine to photograph subject matter that can easily be pushed around to fit within any format that might come to hand. One likely reason would be that Groover had never used this machine before, and therefore wanted to do so, as part of her inexorable march through the whole textbook of photographic technology; a second possible reason might be that perhaps no one has to her complete satisfaction filled that oddly shaped container with a pictorial structure that did not seem slightly opportunistic, a little as if one used it only to make photographs of stretch limos and dachshunds. I suggest this possibility with trepidation, since Georges Braque was clearly fond of the banquet camera format, as was Pierre-Henri de Valenciennes before him. Groover has surely looked with close attention at Braque, and probably also at Valenciennes, and she might object that they had in

fact used the shape perfectly, and that she had no ambition other than to learn their secrets.

These most recent pictures are more relaxed in structure and more open-ended in mood than the tensely artful color still lifes that preceded them. The new pictures are the first to be seen from Groover's new home in the Dordogne, and one might be tempted to say that the new pictures feel more like the French countryside and less like something invented in a loft on the Bowery, except for the fact that Groover's work has always seemed independent of—even coolly superior to—the accident of environment. In any case the new style, in its particular details, is likely soon to be replaced, as Groover moves on to the next phase of her project, the complete outline of which is not yet altogether clear, but which would seem to involve the reinvention of photography and the clarification of its history. It does not seem likely that this project will proceed much differently in the Dordogne than it would anywhere else that Groover might be.

In fact it seems odd to me that an artist's work should be independent of an artist's geographical place; it seems to me too brave, almost superhuman. But Groover has said that Form is All, or something similar, and form we have always with us, and surely will have even during intergalactic travel. In any case, only a fool would argue with the success of so excellent an artist, and only a sentimental fool would feel deprived by her departure from his country. She is not after all playing a team sport.

John Szarkowski
January 1993

[1] Weston expressed the general sentiment many times in many ways, for example, in a 1934 letter to Ansel Adams: "I agree with you that there is just as much 'social significance in a rock' as in 'a line of unemployed'" (*Edward Weston Papers*, ed. Amy Stark. Guide Series Number Thirteen [Tucson: Center for Creative Photography, The University of Arizona Press, 1986], p. 10). Evans' negative definition was part of a statement written to accompany his work in the 1955 Museum of Modern Art exhibition *Diogenes with a Camera III*.

[2] Lawrence Gowing, "Painter and Apple," in *The Arts* (London: Lund Humphries, 1945).

[3] Lincoln Kirstein, in the Introduction to *The Hampton Album* (New York, The Museum of Modern Art, 1966) p. 9.

[4] I have been unable to ascertain whether camera movements were ever incorporated into the camera obscura before the invention of photography, but I would guess that Canaletto enjoyed at least a primitive version of the rising front, which would have allowed him to keep his building edges parallel.

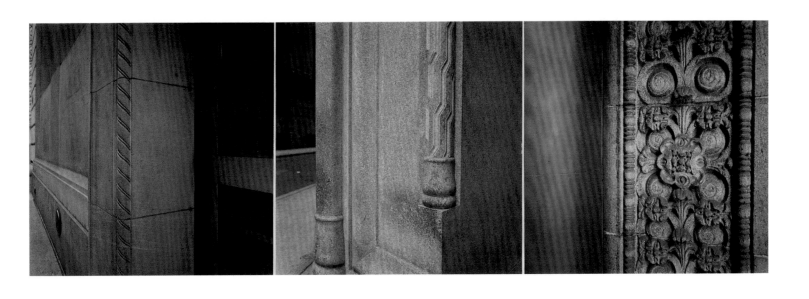

PLATE 6

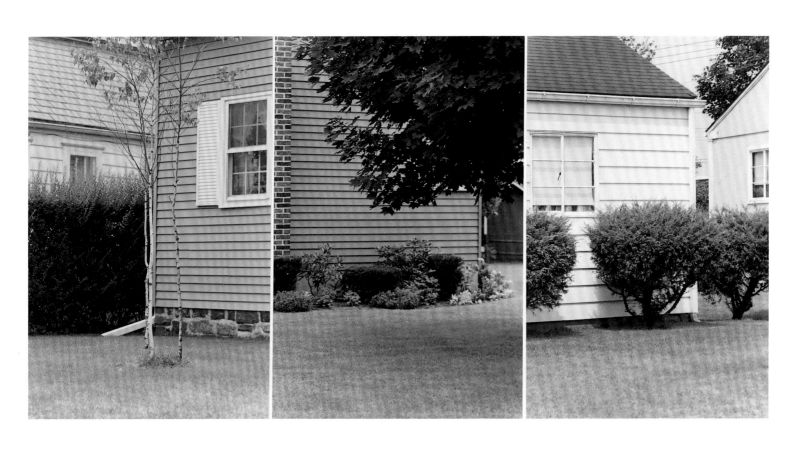

PLATE 7

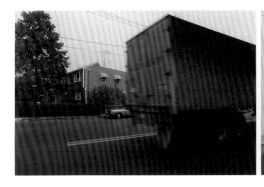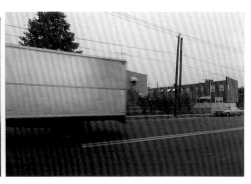

P L A T E 8

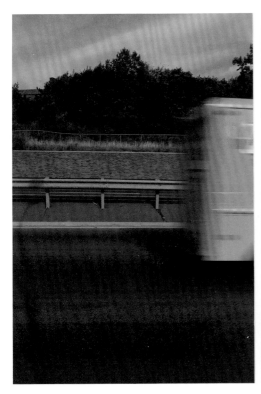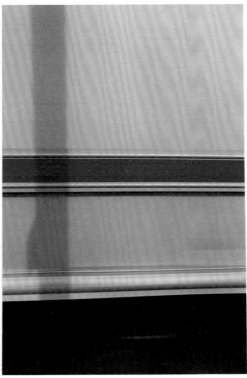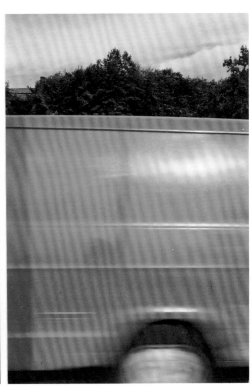

PLATE 9

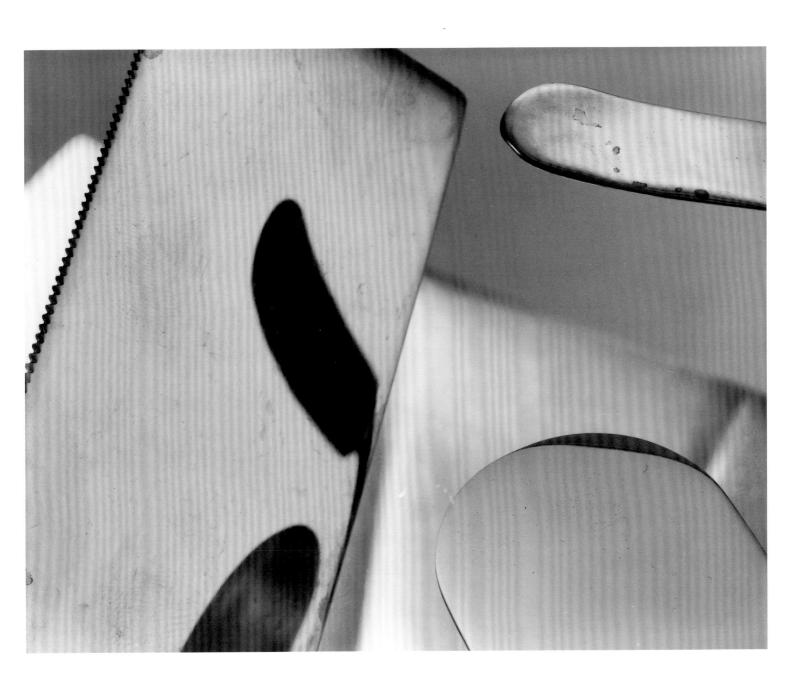

PLATE 10

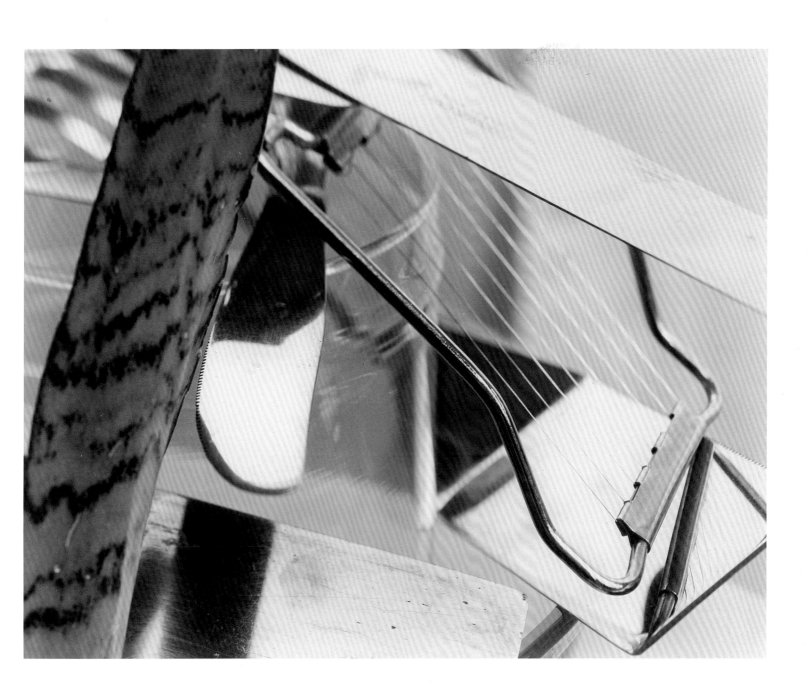

PLATE II

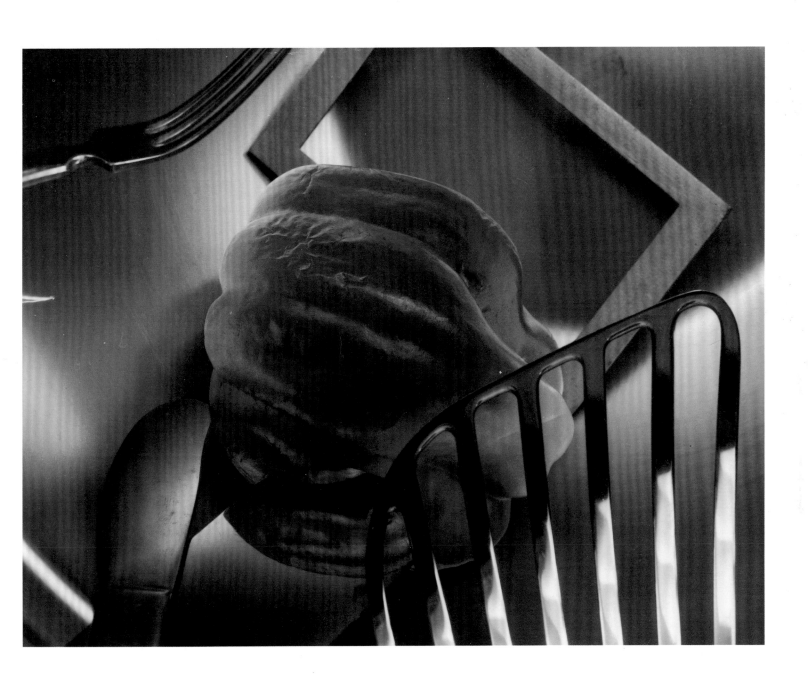

PLATE 12

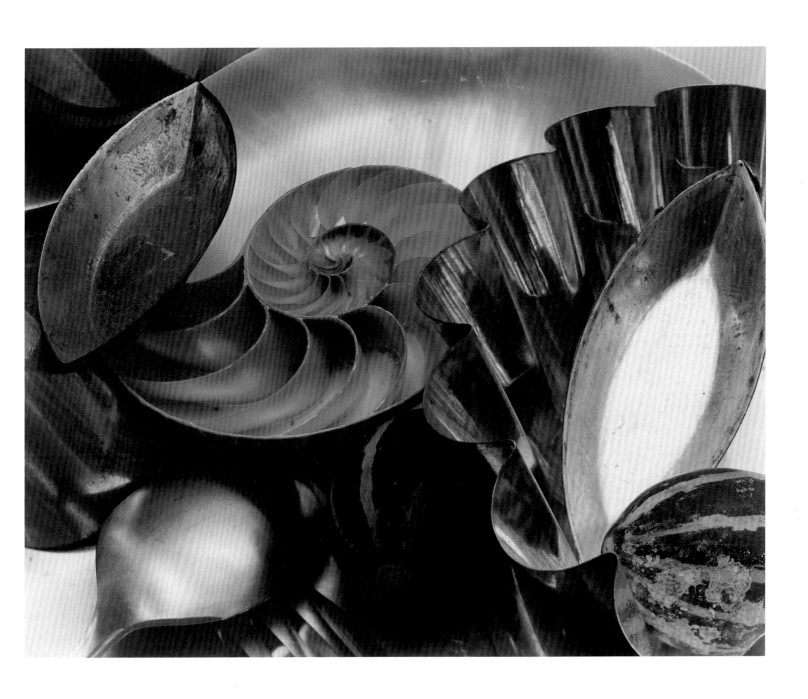

PLATE 13

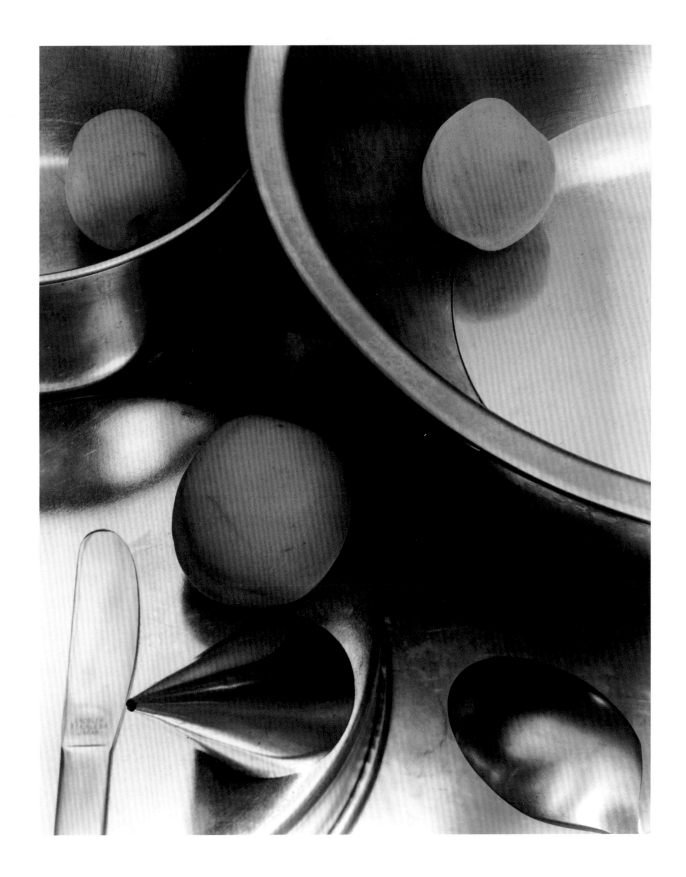

PLATE 14

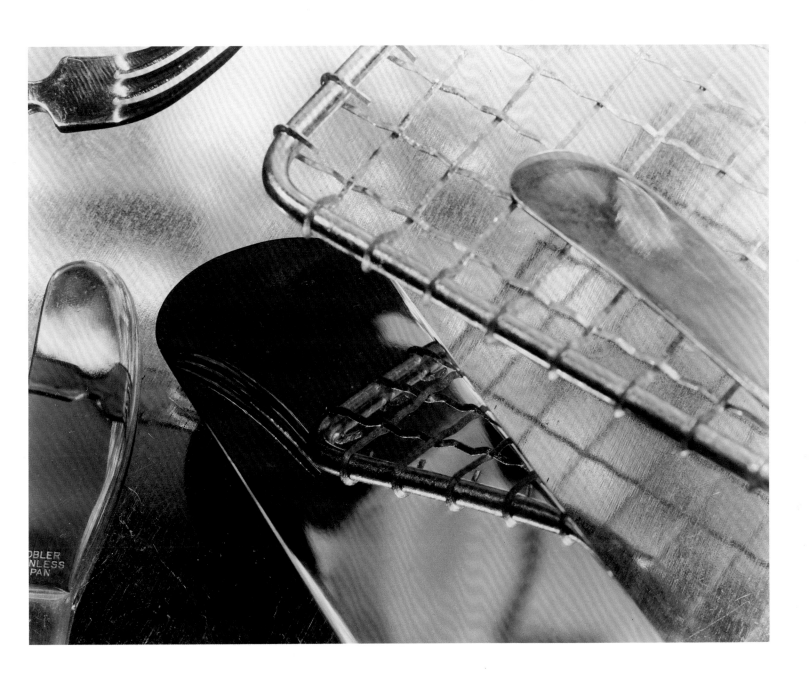

PLATE 15

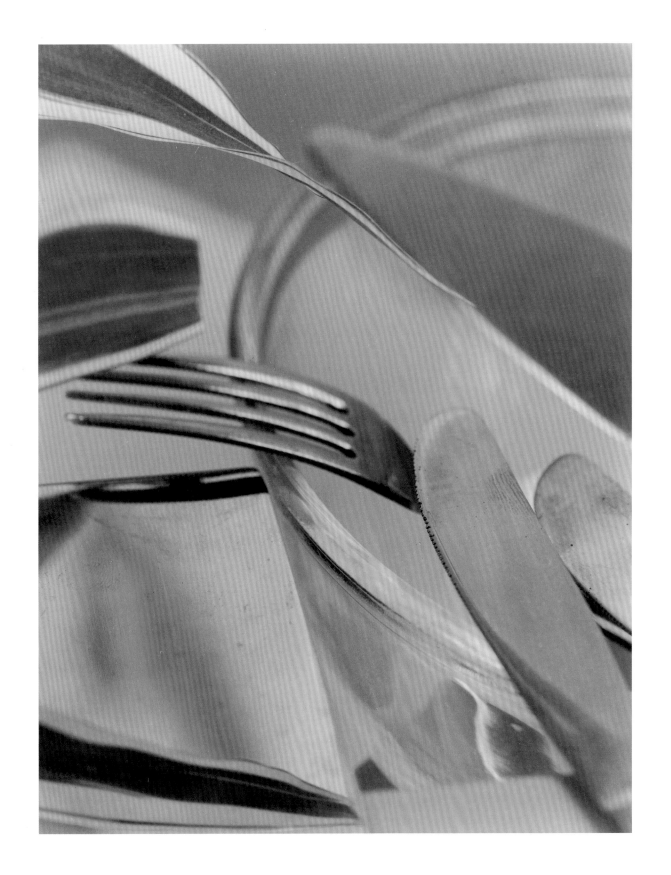

PLATE 16

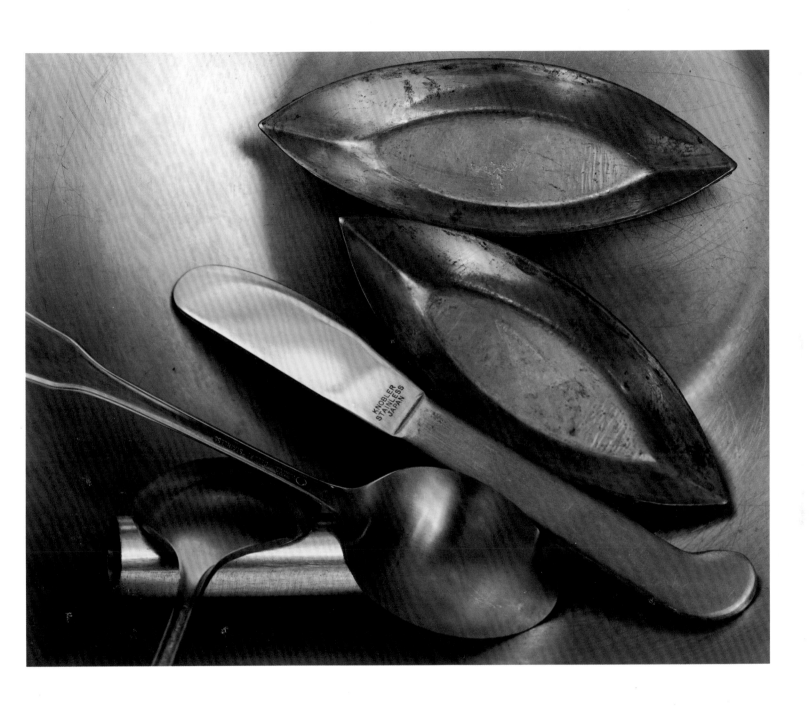

PLATE 17

PLATE 18

PLATE 19

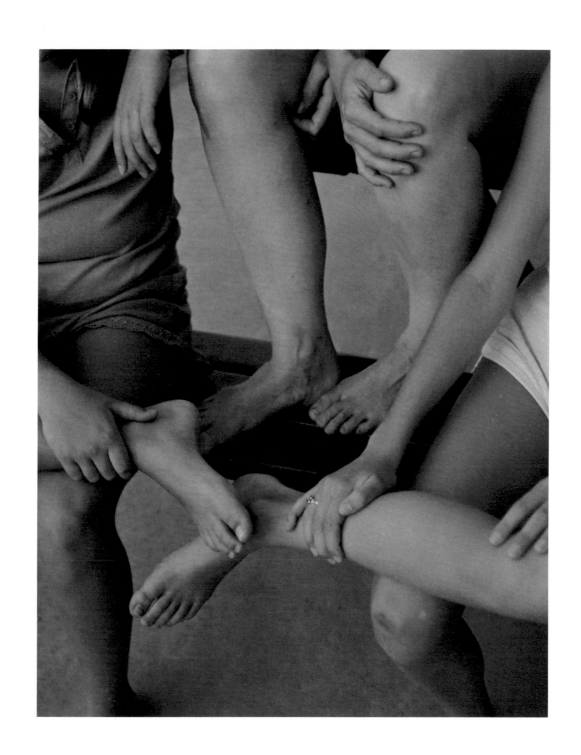

PLATE 20

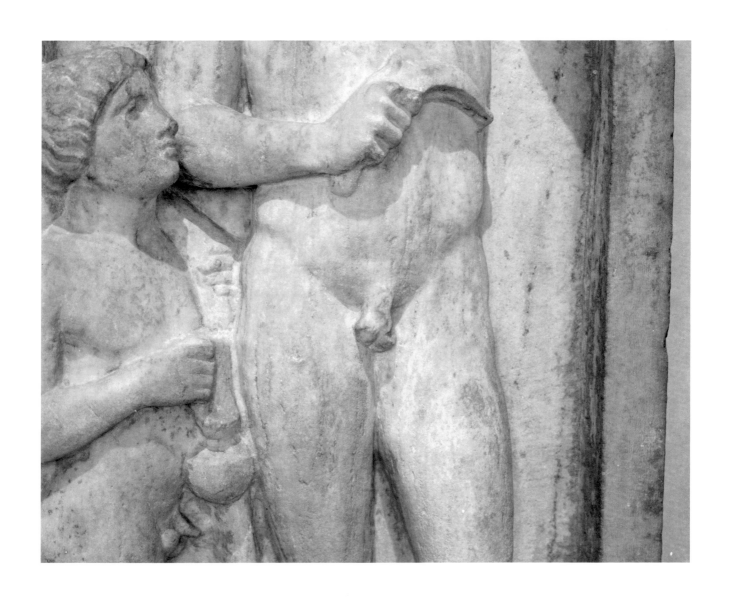

PLATE 21

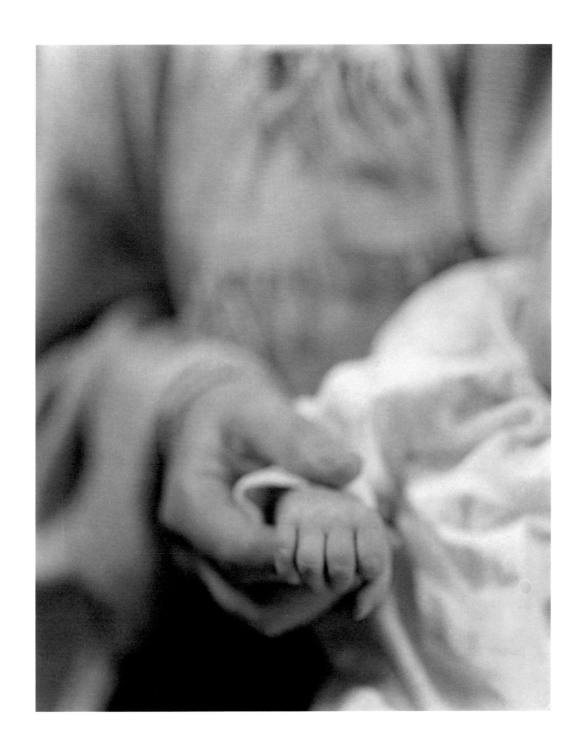

PLATE 22

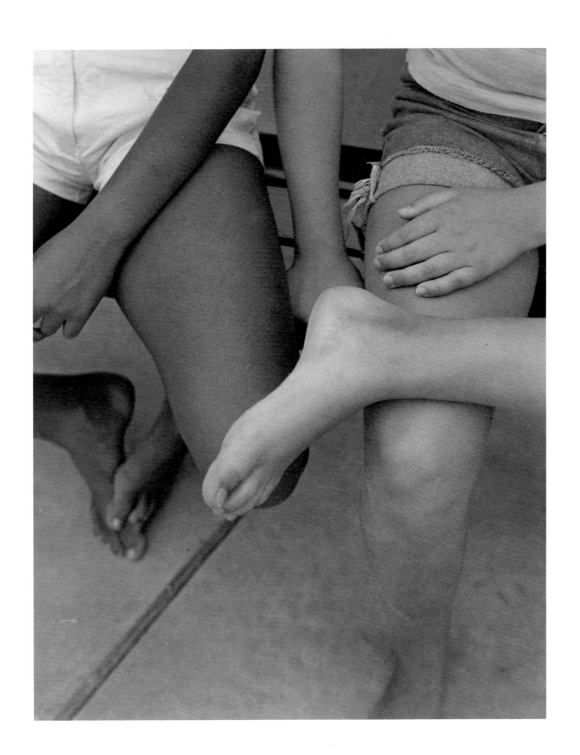

PLATE 23

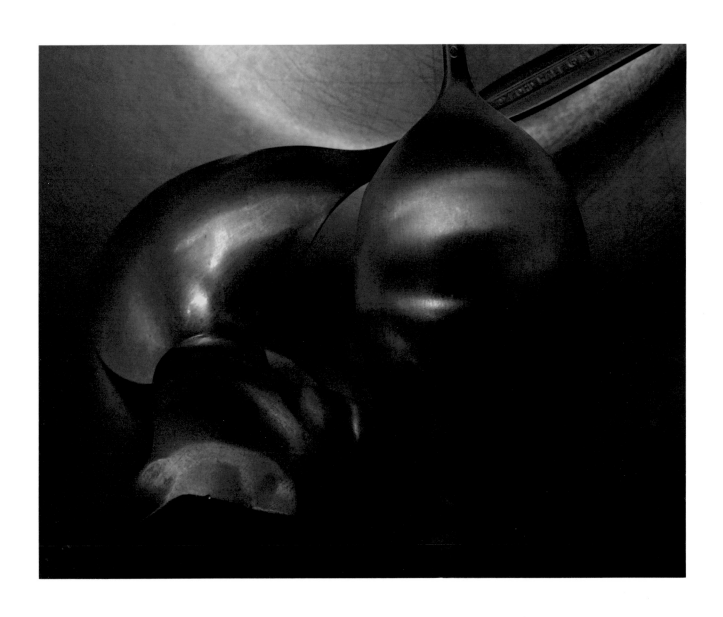

PLATE 24

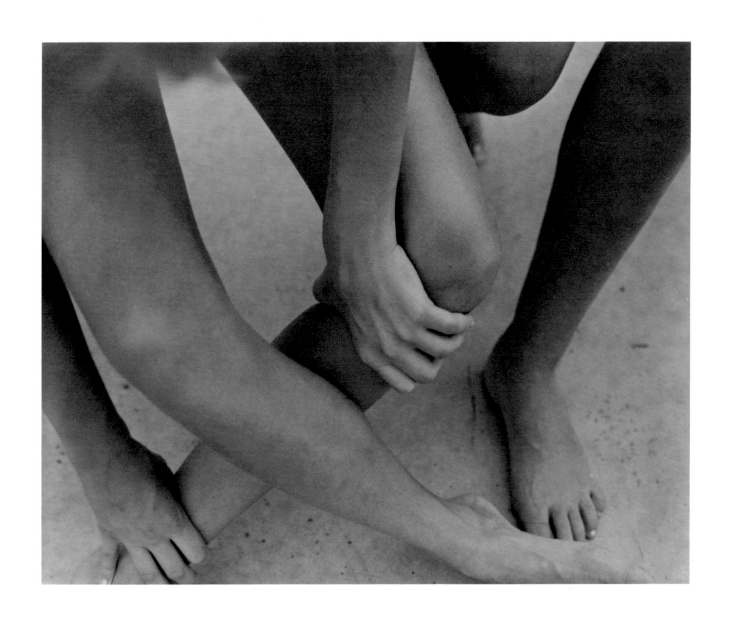

PLATE 25

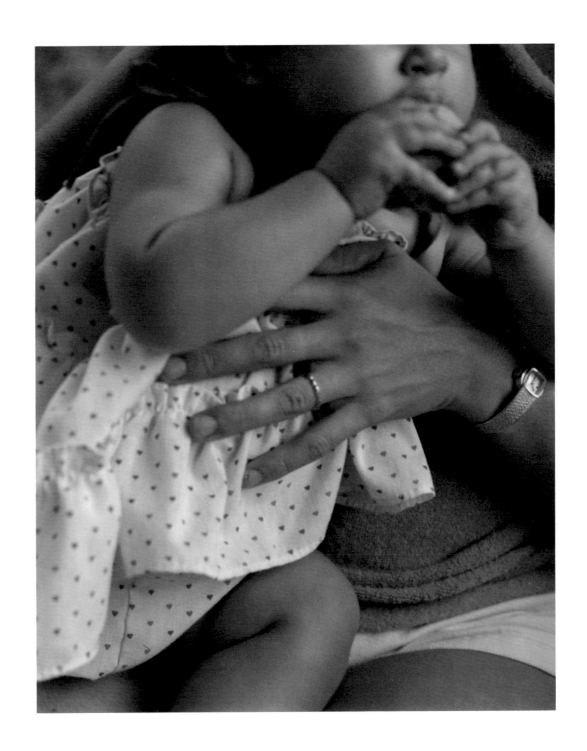

PLATE 26

PLATE 27

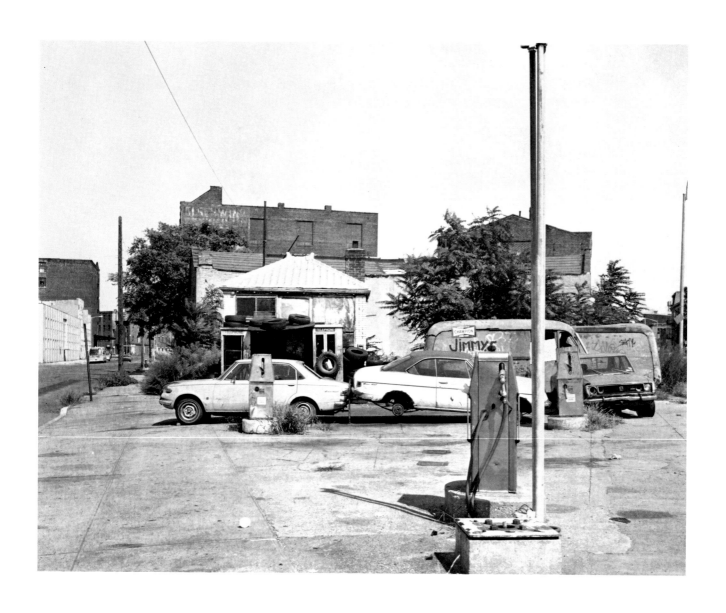

PLATE 28

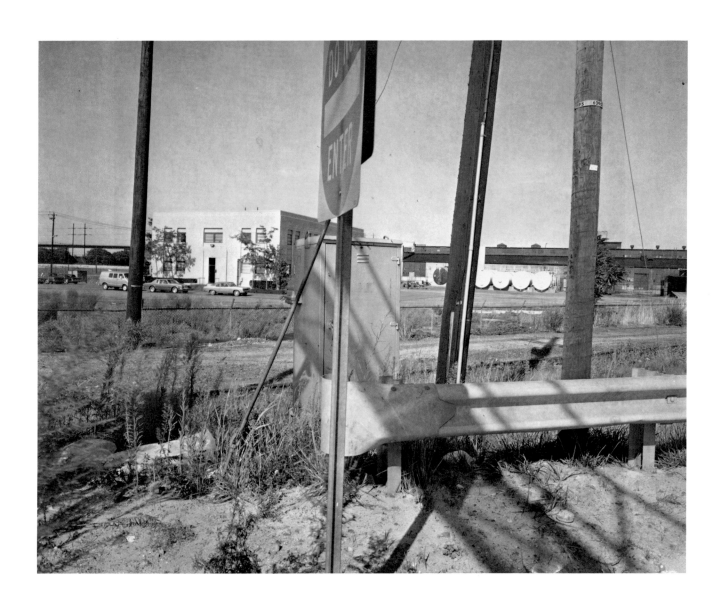

PLATE 29

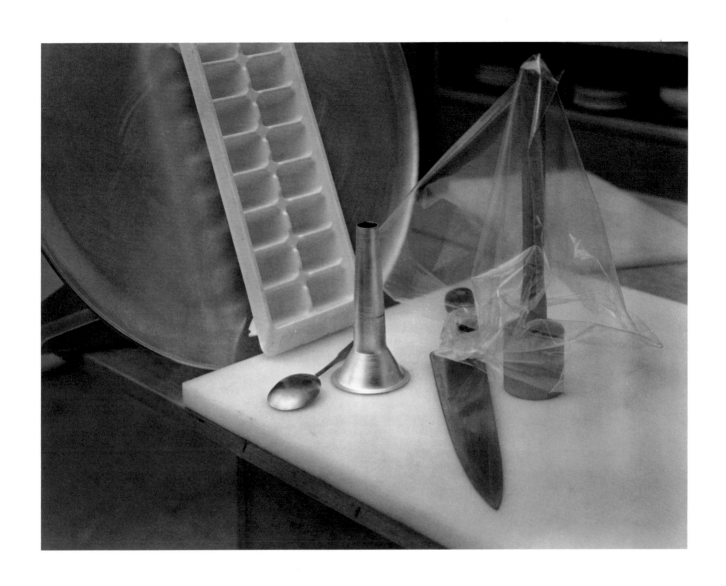

PLATE 30

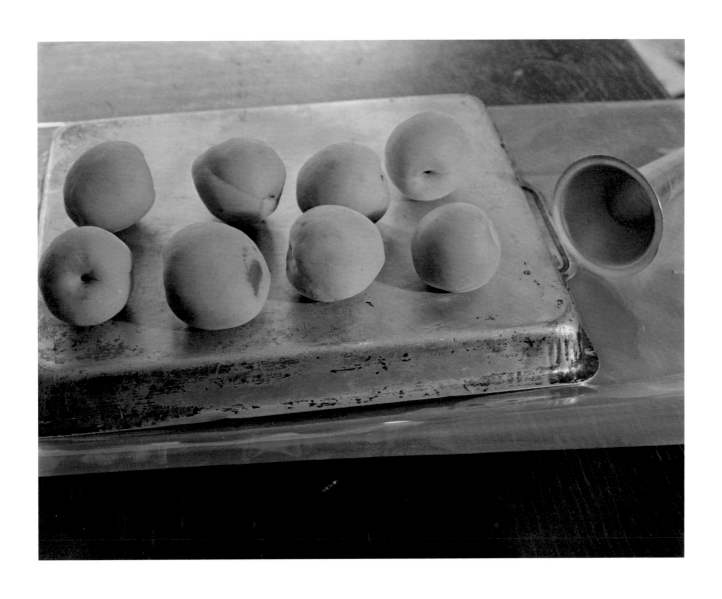

PLATE 31

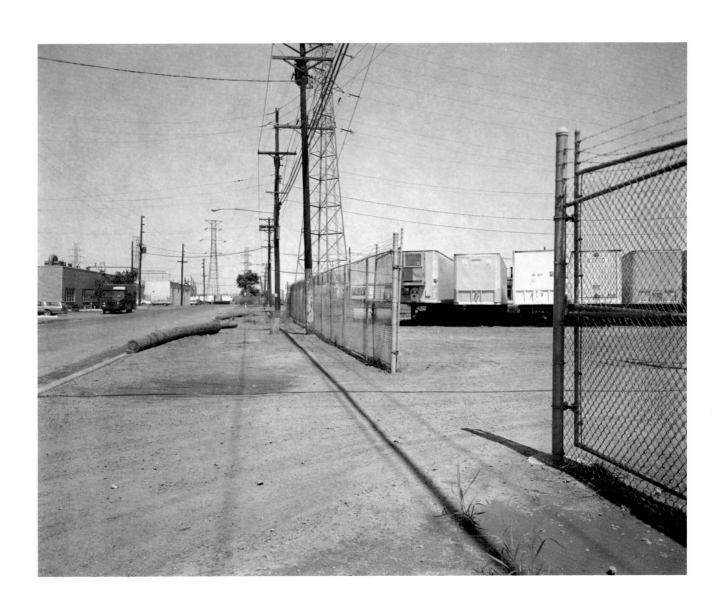

PLATE 32

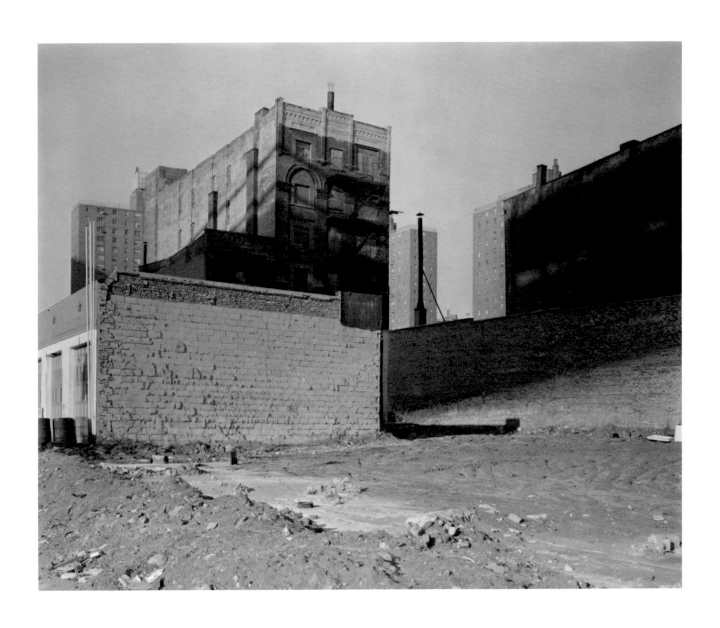

PLATE 33

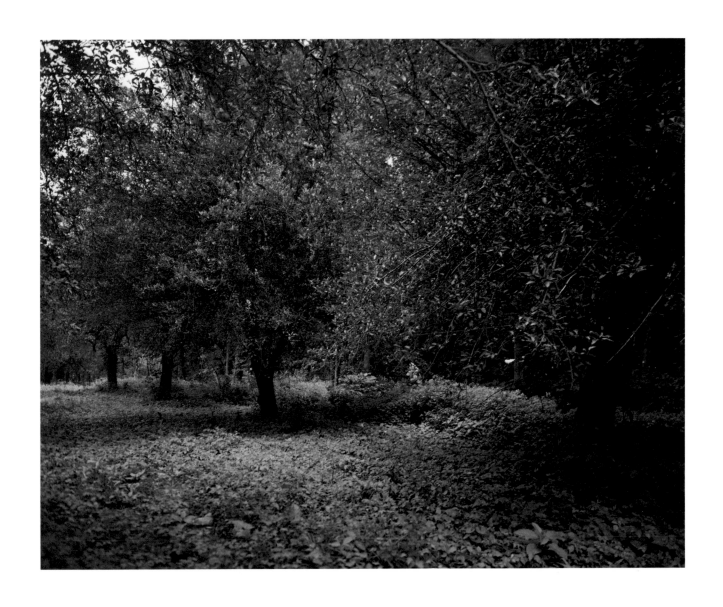

PLATE 34

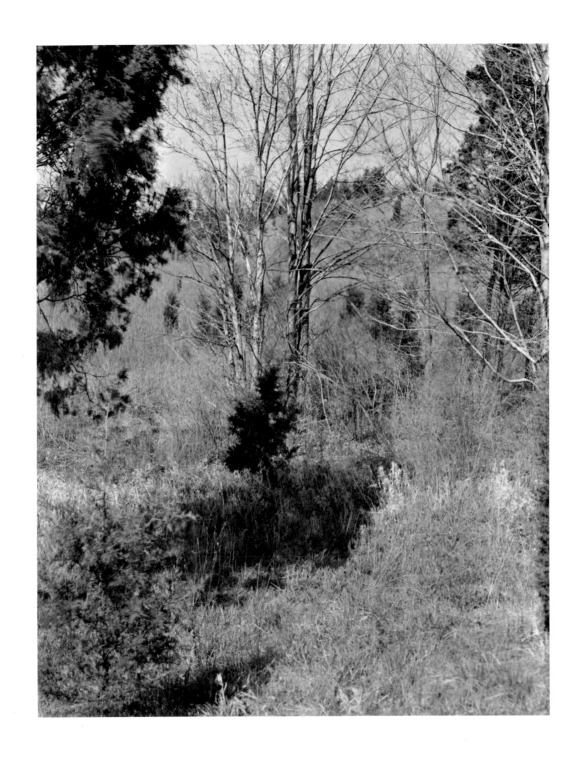

PLATE 35

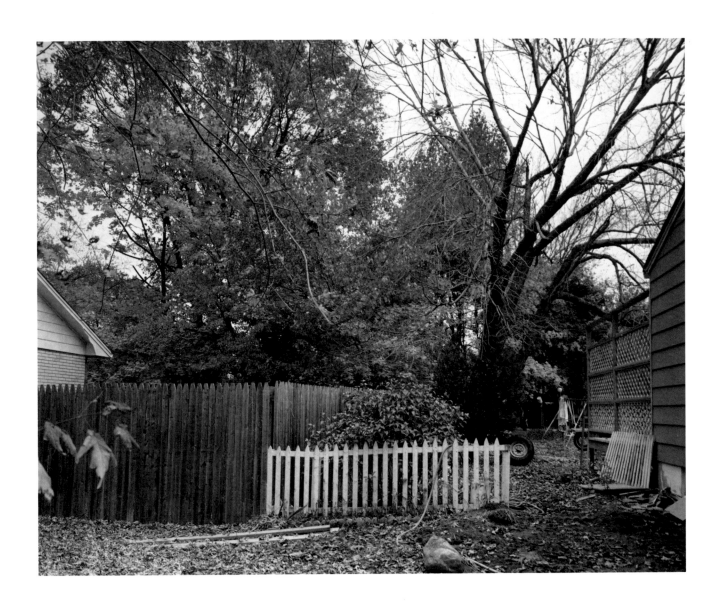

PLATE 36

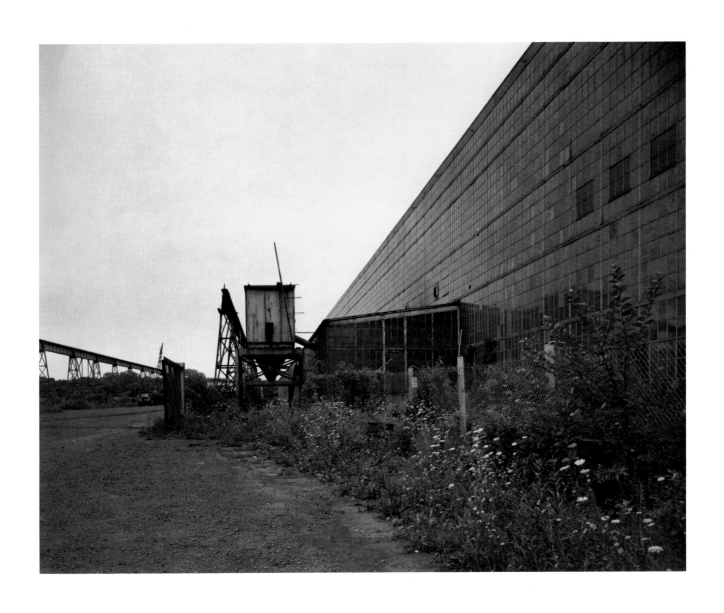

PLATE 37

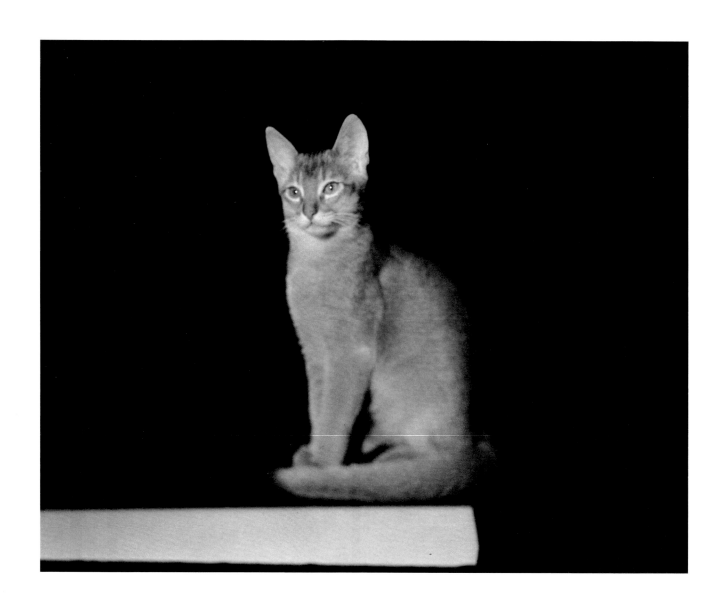

PLATE 38

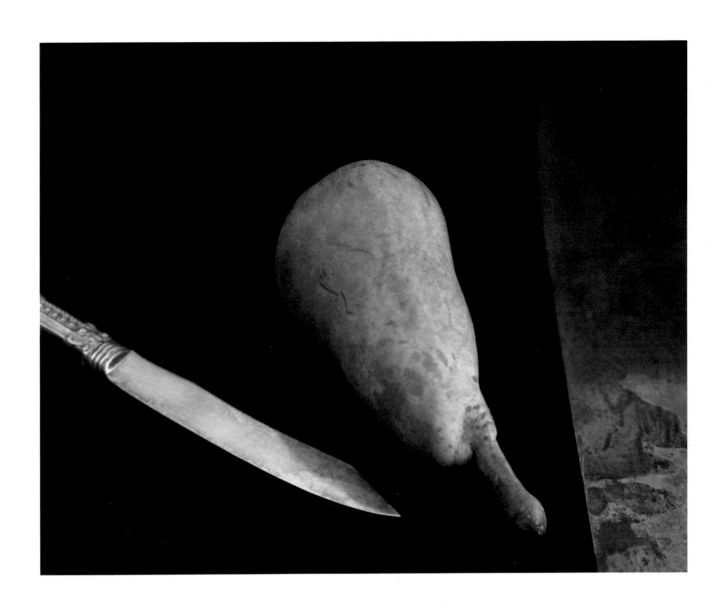

PLATE 39

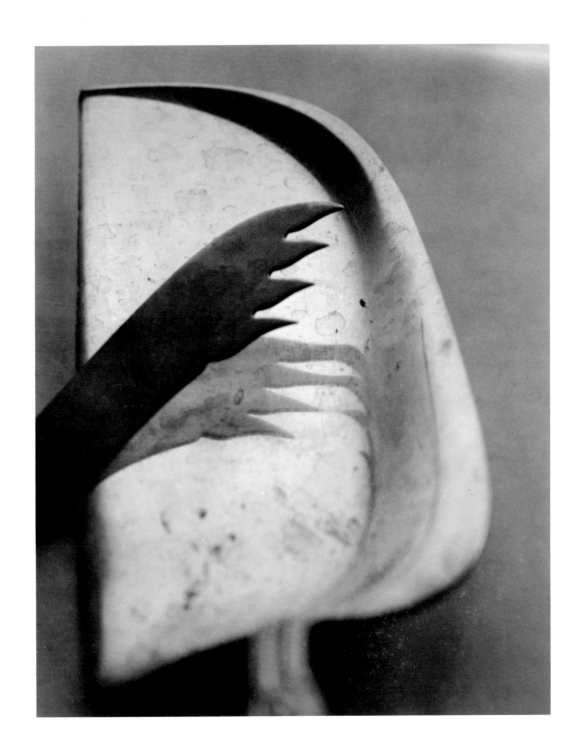

PLATE 40

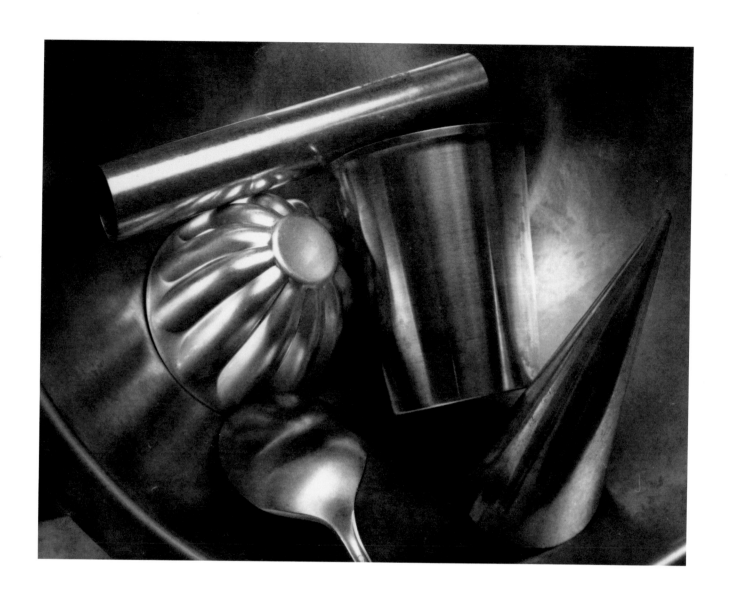

PLATE 41

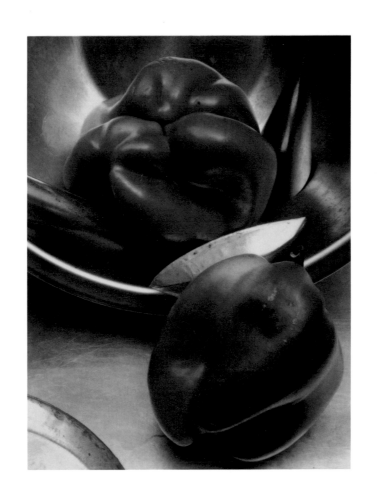

PLATE 42

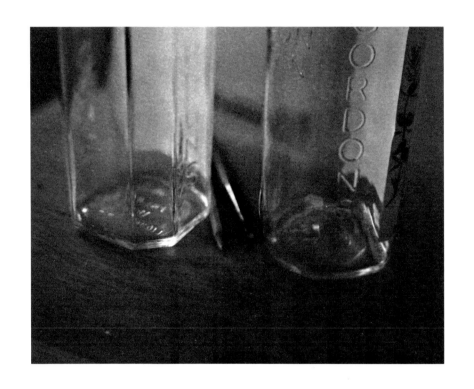

PLATE 43

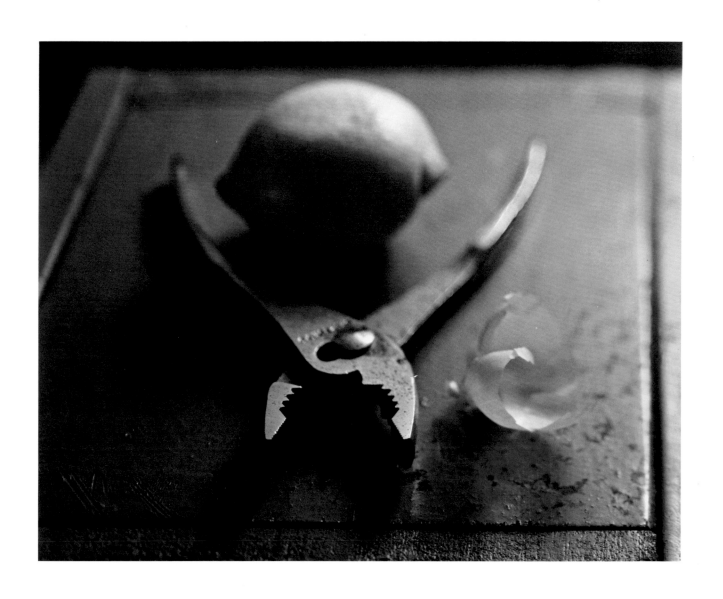

PLATE 44

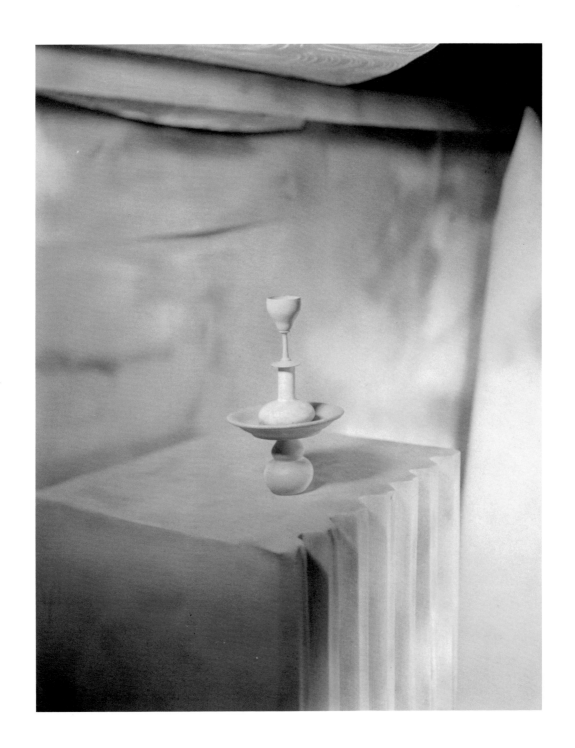

PLATE 45

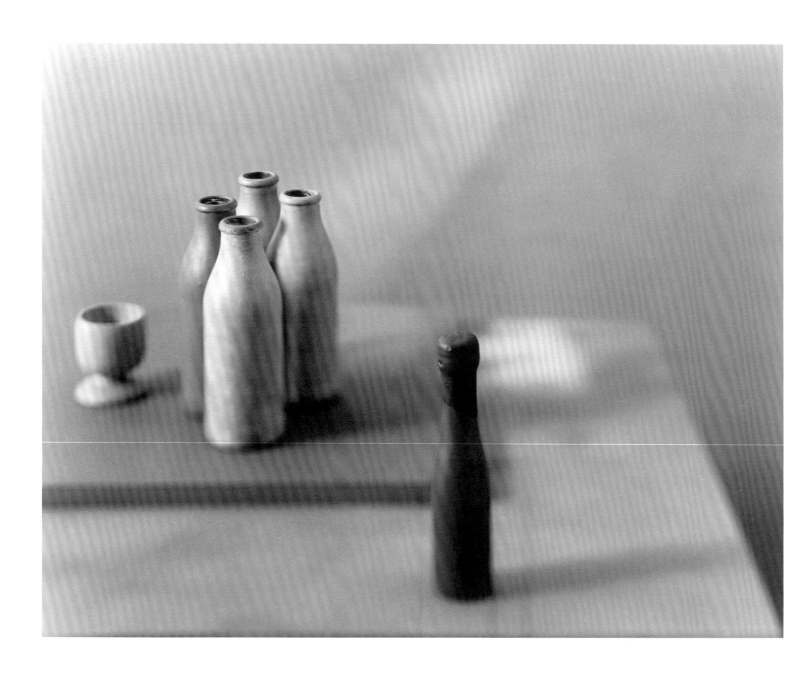

PLATE 46

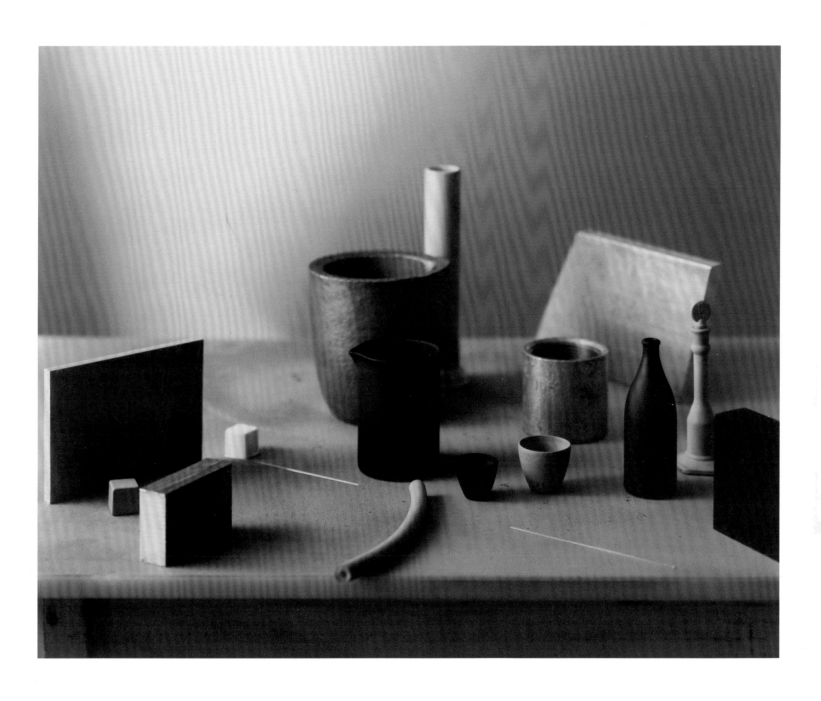

PLATE 47

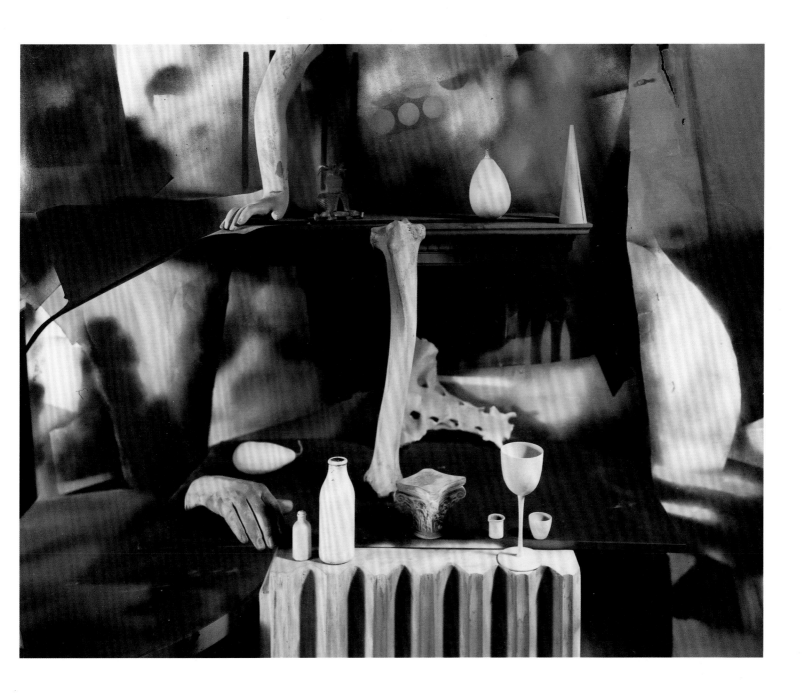

PLATE 48

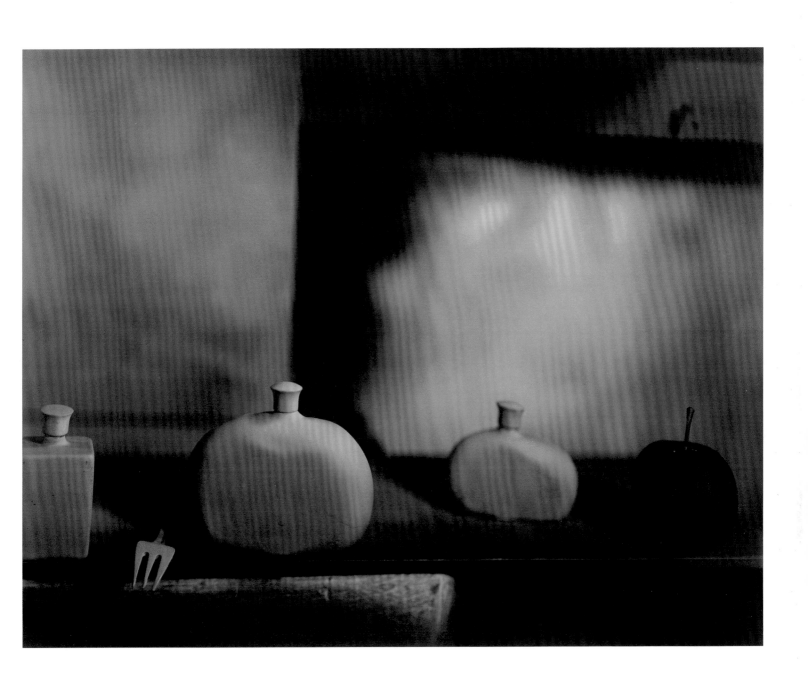

PLATE 49

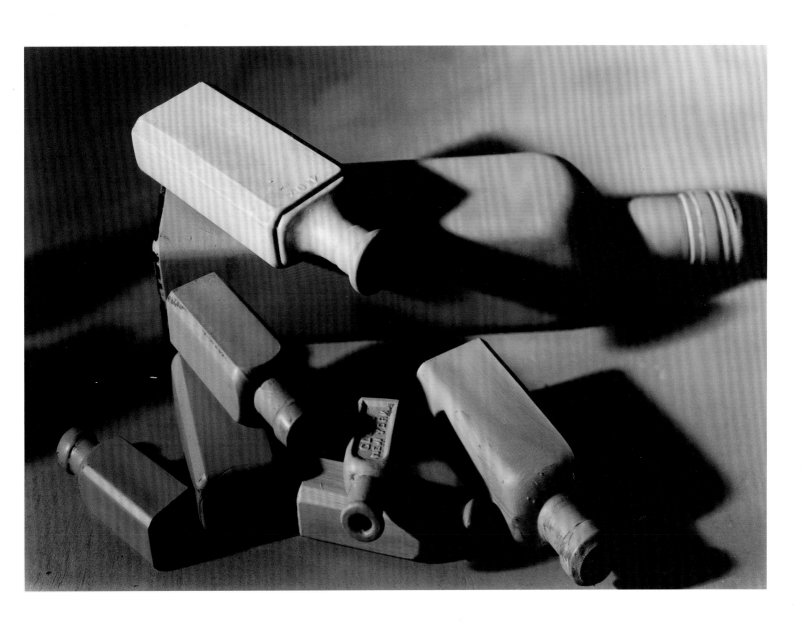

PLATE 50

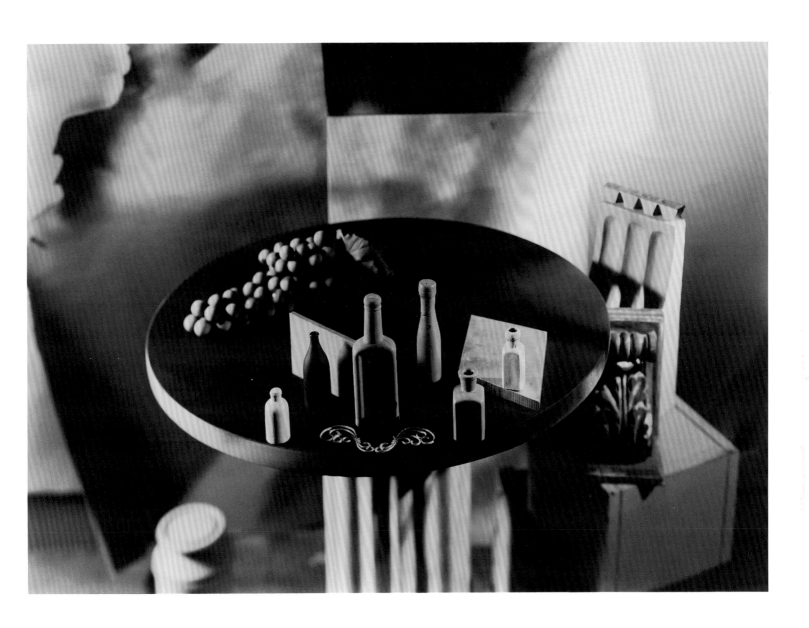

PLATE 51

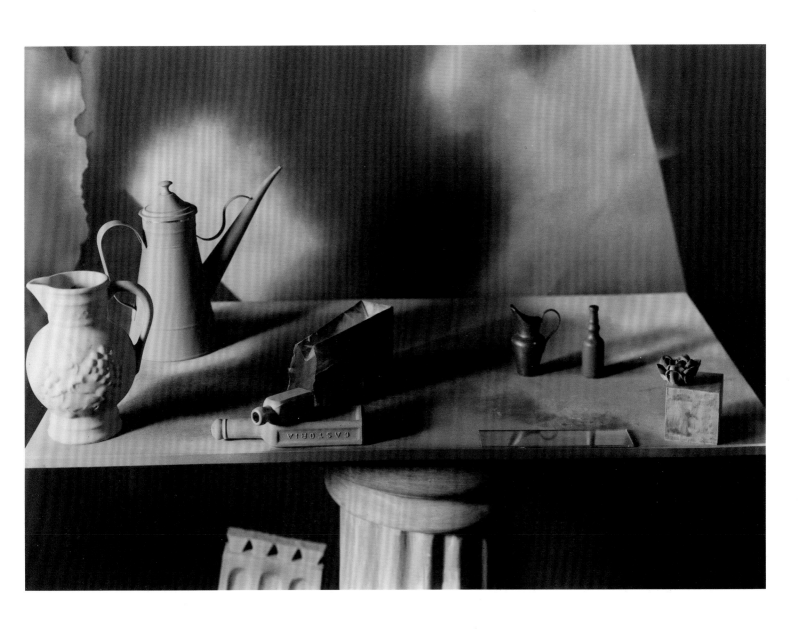

PLATE 52

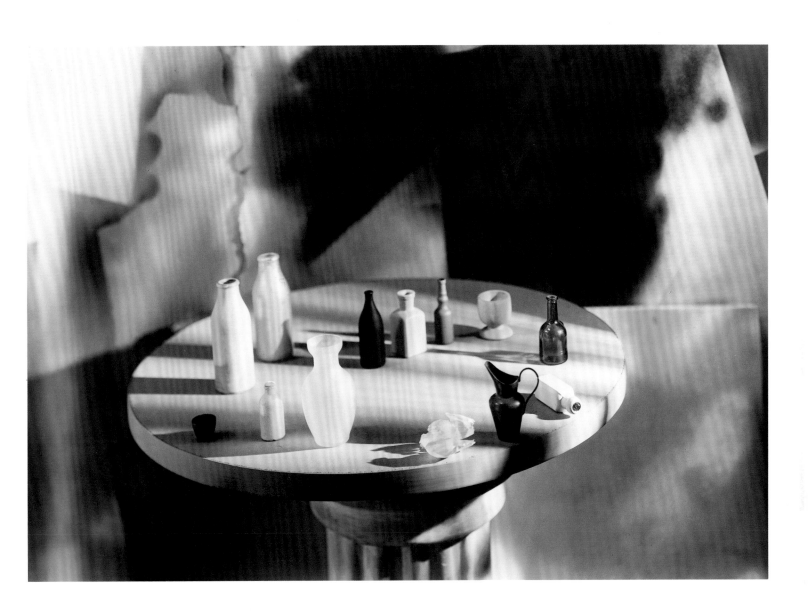

PLATE 53

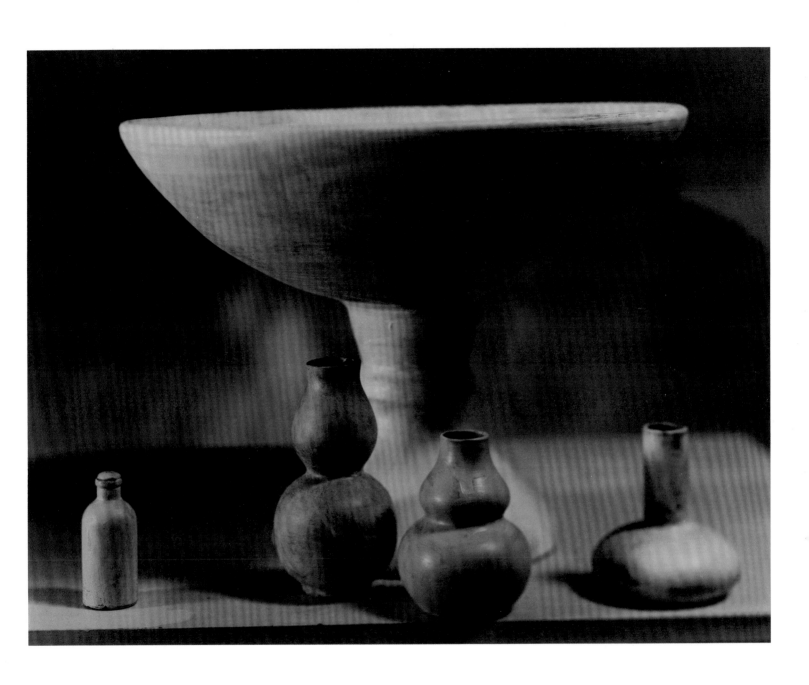

PLATE 54

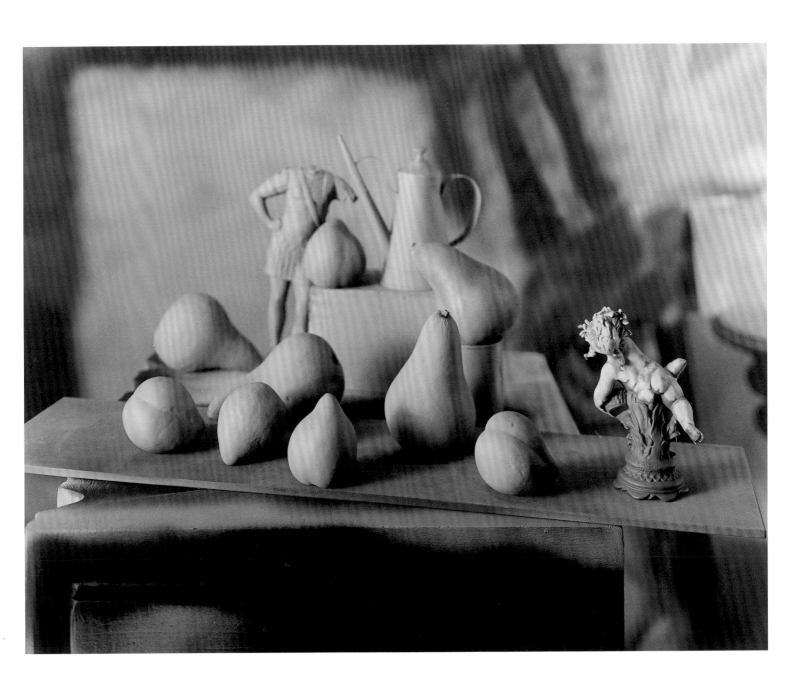

PLATE 55

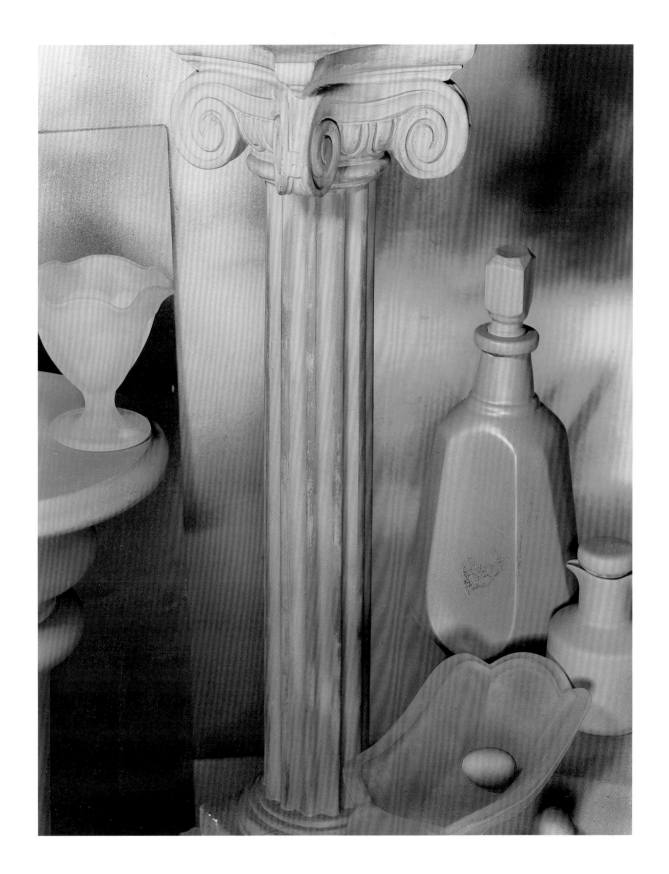

PLATE 56

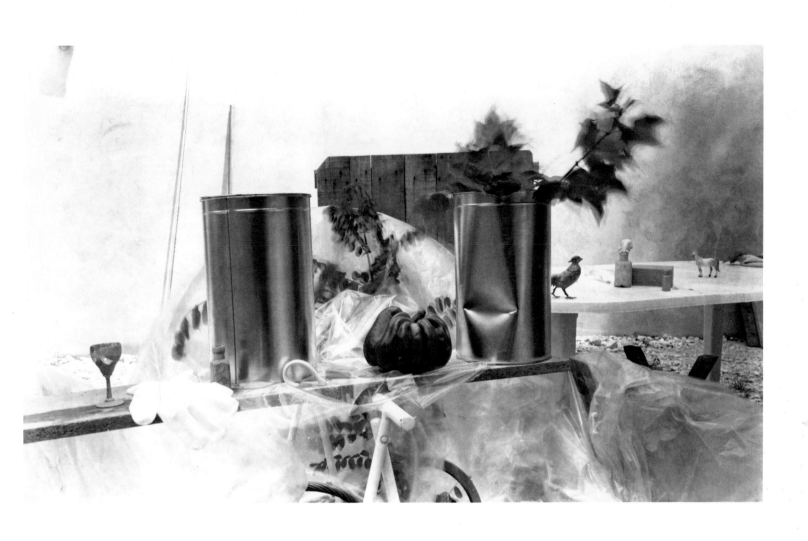

PLATE 57

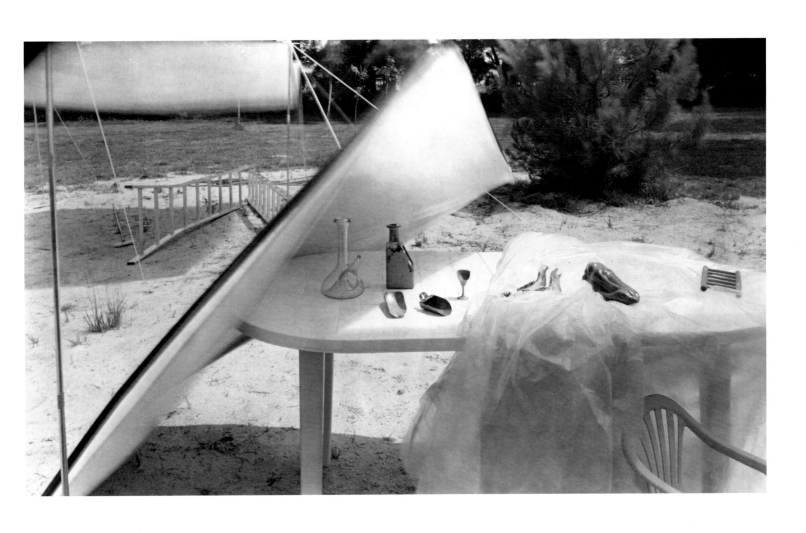

PLATE 58

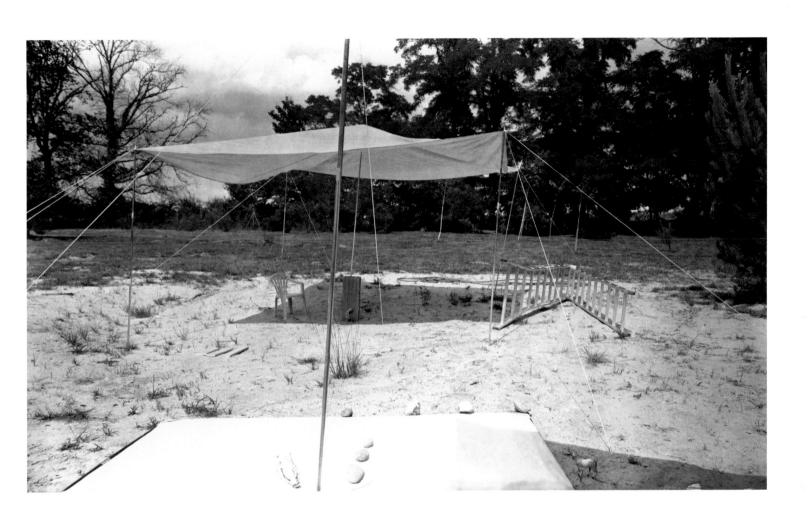

PLATE 59

LIST OF PLATES

Dimensions are in inches and centimeters, height preceding width.
Unless otherwise indicated, all works are courtesy of the photographer
or Robert Miller Gallery, New York.

1 Untitled. 1986
 Palladium print
 8 × 10" (20.3 × 25.4 cm)

2 Statue With Bird. 1981
 Gelatin-silver print
 8 × 10" (20.3 × 25.4 cm)

3 Untitled. 1981
 Palladium print
 8 × 10" (20.3 × 25.4 cm)

4 Untitled. 1983
 Platinum-palladium print
 7 1/2 × 9 3/8" (19.1 × 23.8 cm)

5 Untitled. 1985
 Gelatin-silver print
 11 7/8 × 15" (30.2 × 38 cm)
 Quillan Company (courtesy Jill Quasha)

6 Untitled. 1977
 Three chromogenic color prints
 Each: 15 × 15" (38 × 38 cm)
 Overall: 15 × 45 1/4" (38 × 113.8 cm)
 The Museum of Modern Art, New York
 Acquired with matching funds from
 Mr. John D. Rockefeller 3rd and
 the National Endowment for the Arts

7 Untitled. 1977
 Three Type "C" prints
 Each: 19 × 13" (48.3 × 33 cm)

8 Untitled. 1975
 Three Type "C" prints
 Each: 9 × 13" (22.9 × 33 cm)

9 Untitled. 1975
 Three Type "C" prints
 Each: 9 × 6" (22.9 × 15.1 cm)

10 Untitled. 1978
 Type "C" print
 4 × 5" (10.2 × 12.7 cm)

11 Untitled. 1978
 Type "C" print
 16 × 20" (40.6 × 51 cm)

12 Untitled. 1978
 Type "C" print
 16 × 20" (40.6 × 51 cm)

13 Untitled. 1979
 Type "C" print
 16 × 20" (40.6 × 51 cm)

14 Untitled. 1980
 Type "C" print
 20 × 16" (40.6 × 51 cm)

15 Untitled. 1979
 Type "C" print
 16 × 20" (40.6 × 51 cm)

16 Untitled. 1978
 Type "C" print
 16 × 20" (40.6 × 51 cm)

17 Untitled. 1978
 Type "C" print
 16 × 20" (40.6 × 51 cm)

18 Untitled. 1981
 Palladium print
 11 × 14" (27.9 × 35.6 cm)

19 Untitled. 1982
 Platinum-palladium print
 4 × 5" (10.2 × 12.7 cm)

20 Untitled. 1982
 Palladium print
 8 × 10" (20.3 × 25.4 cm)

21 Relief. 1981
 Palladium print
 2 1/4 × 2 3/4" (5.7 × 7 cm)

22 Untitled. 1990
 Palladium print
 8 × 10" (20.3 × 25.4 cm)

23 Untitled. 1981
 Palladium print
 8 × 10" (20.3 × 25.4 cm)

24 Untitled. 1981
 Palladium print
 8 × 10" (20.3 × 25.4 cm)

25 Untitled. 1981
 Palladium print
 8 × 10" (20.3 × 25.4 cm)

26 Untitled. 1981
 Palladium print
 8 × 10" (20.3 × 25.4 cm)

27 Untitled. 1981
 Palladium print
 8 × 10" (20.3 × 25.4 cm)

28 Untitled. 1982
 Palladium print
 8 × 10" (20.3 × 25.4 cm)

29 Untitled. 1982
 Palladium print
 8 × 10" (20.3 × 25.4 cm)

30 Untitled. 1981
 Palladium print
 11 × 14" (27.9 × 35.6 cm)

31 Untitled. 1981
 Palladium print
 11 × 14" (27.9 × 35.6 cm)

32 Untitled. 1982
 Palladium print
 8 × 10" (20.3 × 25.4 cm)

33 Untitled. 1981
 Platinum-palladium print
 8 × 10" (20.3 × 25.4 cm)

34 Untitled. 1987
 Palladium print
 8 × 10" (20.3 × 25.4 cm)

35 Untitled. 1981
 Palladium print
 8 × 10" (20.3 × 25.4 cm)

36 Untitled. 1982
 Platinum-palladium print
 8 × 10" (20.3 × 25.4 cm)

37 Untitled. 1982
 Palladium print
 8 × 10" (20.3 × 25.4 cm)

38 Untitled. 1984
 Palladium print
 8 × 10" (20.3 × 25.4 cm)

39 Untitled. 1983
Palladium print
8 × 10" (20.3 × 25.4 cm)

40 Untitled. 1983
Palladium print
8 × 10" (20.3 × 25.4 cm)

41 Untitled. 1980
Platinum-palladium print
8 × 10" (20.3 × 25.4 cm)

42 Untitled. 1982
Palladium print
4 × 5" (10.2 × 12.7 cm)

43 Untitled. 1987
Palladium print
4 × 5" (10.2 × 12.7 cm)

44 Untitled. 1985
Gelatin-silver print
12 × 15" (30.5 × 38.1 cm)

45 Untitled. 1990
Palladium print
8 × 10" (20.3 × 25.4 cm)

46 Untitled. 1987
Type "C" print
30 × 40" (76.2 × 101.6 cm)

47 Untitled. 1986
Type "C" print
16 × 20" (40.6 × 51 cm)

48 Untitled. 1989
Type "C" print
24 × 30" (62 × 76.2 cm)

49 Untitled. 1990
Type "C" print
30 × 40" (76.2 × 101.6 cm)

50 Untitled. 1987
Type "C" print
18 × 22" (45.7 × 56 cm)

51 Untitled. 1988
Chromogenic color print
16 7/16 × 23" (41.7 × 58.5 cm)
The Museum of Modern Art, New York
John Parkinson III Fund

52 Untitled. 1988
Type "C" print
16 × 22" (40.6 × 56 cm)

53 Untitled. 1988
Type "C" print
18 × 22" (45.7 × 55.9 cm)

54 Untitled. 1989
Type "C" print
30 × 40" (76.2 × 101.6 cm)

55 Untitled. 1989
Type "C" print
30 × 40" (76.2 × 101.6 cm)

56 Untitled. 1990
Type "C" print
30 × 24" (76.2 × 61 cm)

57 Untitled. 1992
Palladium print
12 × 20" (30.5 × 51 cm)

58 Untitled. 1992
Palladium print
12 × 20" (30.5 × 51 cm)

59 Untitled. 1992
Palladium print
12 × 20" (30.5 × 51 cm)

JAN GROOVER
PHOTOGRAPHS

Edited by Constance Sullivan

Designed by Alex Castro

Tritone separations and production supervision
by Robert Hennessey

Printed by Meridian Printing, East Greenwich, Rhode Island

Color separations by Elite Color Group, Providence, Rhode Island

Bound by Riverside Book Bindery, Rochester, New York

Type set in Centaur and Gill Sans Light